Gérard Depardieu

INNOCENT

TRANSLATED *by*
RAINER J. HANSHE

Contra Mundum Press New York · London · Melbourne

First Contra Mundum Press
Edition 2017.

Library of Congress
Cataloguing-in-Publication Data
Depardieu, Gérard, 1948–
[*Innocent*. English.]
Innocent / Gérard Depardieu;
translated from the French by
Rainer J. Hanshe

—1st Contra Mundum Press
Edition
168 pp., 5 x 8 in.

ISBN 9781940625249

 I. Depardieu, Gérard.
 II. Title.
 III. Hanshe, Rainer J.
 IV. Translator.

2017947793

TABLE OF CONTENTS

FRIENDSHIP

Friendship is a question mark.

It exists perhaps only in childhood.

Friends are the people with whom we grow up. We go fishing together for the first time, we spend nights together outside, we steal cherries, we get caught red handed, we support each other. Friends are the people with whom we touch the willy too, we discover and develop ourselves, we live all of our first times together.

We believe a lot in friendship, then things deteriorate a bit. It's not the same thing anymore since time changes, lives change, even molecules change.

At fifteen we're not the same as when we're forty, still less that of a man of seventy.

So we can think of friendship as a flower: it grows, it fades, it disappears, then the following season, it can return like a peony that was believed lost but which suddenly reveals itself, splashing its most beautiful colors.

When you're my age, many of your friends have already left.

And since you know that you will no longer see those people who have disappeared, you remain with the idea of that past friendship.

In spite of everything, we still try to believe that other friendships are possible.

Even if the word friendship has become a bit obsolete. Even if we live in a society where friendship no longer exists. Even if we know that to be human is to always betray. To be human is to kill.

In spite of everything, we say that there are perhaps friends whom we don't know, people who love us from afar and who we could love. Still, it's necessary to make the first step … and sometimes, it's tiring.

What most worried me when I left Châteauroux was not to have school buddies. Even if I had realized that mine were often morons or the children of morons. Because, in Berry, where the houses were narrow, where the doors were narrow, & where the people were often narrow, I was only defined by the place that I came from, the people who had raised me, & their reputation.

We were a family of Indians.

And I had often heard parents say to their children when pointing their fingers at me: "I don't want you to play with him! He's a thug!" I heard that, but it didn't bother me. I wasn't very affected by narrow mindedness back then.

But just to leave those buddies, it takes courage. Because we never know what we're going to find after.

Because maybe we'll find even worse.

So I wandered alone for a long time, telling myself that I would never find friends.

I was mourning my school playground.

It's a bit like a first love — you're in love with someone, and then there's a rupture. And it takes time to fall in love again. Except that there was no first love. I had life to live and I was curious about what was going to happen. Even if I had no real ambition. Just keep silent, smile, and look likeable enough to slip through the cracks.

It took one brief year: I had seen something else; I had invented something else. I had read Jean Giono's *The Song of the World*, which gave me the idea to take off, to hit the road. And then, on my way, I had met other people. People who had the same desire for life as me.

People like Marcel Dalio, like Pierre Brasseur, like Michel Simon.

Marcel Dalio and I both played Israël Horovitz at Gaîté-Montparnasse. Him, *The Indian Wants the Bronx*, me, *Clair-Obscur*. I would wait for him at the exit of the theater and we would travel together under the stars. Marcel was always made up, by day as by night, acting or not acting. He was an extravagant character, the kind you don't see anymore nowadays. My Marcel, he was like my Jean Carmet, but I met him before. He was about the same size. He also had moments of intense despair because he was too lucid. But his immense culture and an incredible sense of derision used to help him carry on. Life had taught him to overcome his fear. He said to me: "Never say no, always say yes, *oui*!

4

That's how I made a career in America!" He was someone who had survived everything, too. A Jew who had escaped the Nazis. He was a vibrant soul, a touching man, very spiritual too, in every sense of the word. He made me accept many things about myself, Marcel. That little fellow could never believe that he had a career in America. He had, like Jean, the genius of humble people. And humble people, they are the only ones I really like to approach.

After leaving the theater, Marcel and I used to pick up Pierre Brasseur, who was playing in Marc-Gilbert Sauvajon's *Tchao!* at Théâtre Saint-Georges. And from the Saint-Georges, the three of us would join Michel Simon at the Folies-Bergère, who was always in the front row, checking out the dancer's asses. And he loved that. The dancers knew he was there, they were showing off in front of him, just to please him. He would spend the rest of the evening talking about that. He only talked about that.

Afterwards, we would spend the night walking from one bar to another. We made our rounds. I was in my twenties, I didn't know a tenth of the films they had made. I had nothing to say, but I would listen. I listened to them. I didn't even want to learn, just being with them, having fun together was enough.

There was booze, grub, drinking a lot, eating a lot. Alcohol made Brasseur a bit of an idiot, but it didn't prevent him from having an outlandish imagination.

He could be completely outrageous. One day, he had a fight with his mistress, who ran a restaurant. To get revenge, he went to her restaurant when it was full, crouched in the middle of the room, and dropped his pants and defecated in front of the customers. Before he realized that he was mistaken about the address! It was the lifestyle of those extraordinary characters. Jules Berry was of the same nature; we even had to tie him to the cart in *Les Visiteurs du soir*, because he could no longer stand when so drunk. It didn't prevent him from being exceptional.

Michel Simon was also an exceptional being, someone who was terrified of himself. It must be said that we made up so many stories about him, people fantasize about him so much ... there's nothing worse. I endured that too ... the number of things I supposedly did with all the people I had never met, in all the places I had never been ... Michel was a brilliant actor, as much in comedy as in tragedy. He had started with Vigo, with Renoir, then he had difficulty finding people strong enough to express the entirety of his talent. When I met him, he was vegetating a bit. He had a roughness that spared few people, especially not me. He was not tender with anyone. But being shaken by such a character was a joy. He was bursting with life. Whatever spite he would utter, there was a smile in his eyes; there was always a glimmer of immense humanity.

In Marcel Dalio's eyes, there was infinite tenderness & sweetness. He was interested in life and in others far more than anyone. It must be said that he had long been obliged to be extremely vigilant about his entourage, to be wary of everything, especially that very French behavior, in the style of Marcel Aymé, where you always have a type who watches you behind closed shutters, wondering what you're doing. That snooping type that before, during, and even after the war cost the lives of many people. The awareness that Marcel always had about people and things is what enabled him to survive, and then it became second nature to him.

Much later, I had had the same friendship with Paul Meurisse, who was a *danseur mondain* at La Coupole & who told me that he put a banana in his underwear before inviting women to dance.

Then with Bernard Blier and Jean Gabin, who did everything to include me in their films, despite others' discontent.

All those men were somewhat like my fathers, and I think that they found a bit of their childhood in me, a certain folly that wasn't foreign to them. They were in the cinema, of course, but that's not what I was interested in. I only wanted to be with them; they had become my friends, my family. I didn't like them because they were actors, no, but because they were magnificent beings with their lives, their excesses, their desires, their fears. They trusted me, and I wanted them to be proud

of me. The cinema, I didn't care, I just didn't want to disappoint them. Even if sometimes I did.

During the filming of *L'Affaire Dominici* in Sisteron, I was still a bit wild: I had uprooted a do not enter sign. Gabin had got in my face: "We're already poorly regarded, if moreover you go on like that..."

With Jean, I learned a lot of things ... Especially at the table. I who always tasted everything and never in small quantities; there, I was given what I wanted. We used to start around eleven in the morning, and it was appetizer, fish, game, cheese, dessert. And all that washed down with burgundy. Before beginning to shoot in the early afternoon.

Jean was a bear, and like bears, which are myopic, he didn't want to see far. Because he already knew everything. He had seen everything. He was very discreet. One of his prime interests was eating well. About food, he could expound, like Michel Simon about sex. Jean, he was French as the French can be loved. With the balls of the French. But it was a different France; it was the France of Jean Renoir.

With Gabin, with Blier, with Audiard, the conversations were such a pleasure because the word was first rate. They had that quality which is so lacking today: *refinement*.

After, there was Jean Carmet. Jean, he was a saltimbanque. I met him along the way. With Jean we had the same breaths, the same words. One could go on for

hours without saying anything and then the word came back, then it was the word, the flow & the force of the word. He was never in a hurry when he was with people he loved.

Jean met my parents. The introductions weren't complicated, "Dédé, Lilette ... lil' Jean," and it was done. Dédé pulled out an old bull-shaped bottle, poured us a shot of brandy, Lilette gave us some mother of vinegar. There was no need to talk at all. We came from the same place. Jean and I were country boys, too, and he also had an authoritative father, a bit crazy, also a guzzler. He had always been fascinated by trains, so one day he took one. It took him to Paris, and since he was a very good traveling companion, he met people with whom he could laugh, as I did a bit later. People with whom he could live and party. Without risking, as now, to see his face on the front page of a newspaper because he had been excessive.

It was the time of the Audiards, the Blondins, the Fallets: all those literary anarchs with big mouths, whose language was infused with intelligence. They were all passionate about cycling; it was the time when cycling would make the headlines, but not because of drugs.

It was a time when one could still live one's passions, turning them into an art, without the bad side of things being emphasized right away.

It was a totally different France.

It was pre-1968 France, the one before the revolution of all those young guys fighting against their right-wing bourgeois families, who later became the editorial directors of left-wing newspapers and who, like the worst Bolsheviks, had once more stirred up the French characteristic that Marcel Aymé denounced: a France of the purge & denunciation, a France of the "yes but," where everything must be clean, that so-called cleanliness in which all of us are dying.

CINEMA, IT'S THAT, TOO

CROWNS OF FLOWERS

The young Pierre Niney, who received the César for best actor for his interpretation of Yves Saint Laurent, thanked the "profound benevolence" of the voters, "that benevolence so important to acting," that "necessary benevolence."

Since when should the cinema be benevolent?

The cinema is not benevolent; the cinema must above all not be benevolent.

The cinema must be full of dangers, of hellburners, of dynamite, of burning stones that one tries to juggle.

Art, whatever it may be, true art, has always been the opposite of benevolence.

To be of value, art must be dangerous.

Like the art of the young tightrope walker that I saw falling in front of his father's eyes on Place Voltaire in Châteauroux when I was young.

Artists are all circus people.

And their art is a journey, a journey that begins with deep thinking, because we know that with all the things that we have to express, we have to take a dangerous path alone and face the consequences alone.

And if that process requires psychological understanding, its first concern is not benevolence. What motivates it above all is truth.

The cinema must be true, that is, *dangerous*.

The very great actors are everything but benevolent. I don't even believe in the so-called sensitivity of the actor. When they are real artists, actors are wild, they are cruel, their way of apprehending things is painful and violent.

And it's the same with directors.

When I think of Michelangelo Antonioni, when I think of Marco Ferreri, of Jean-Luc Godard, of Bertrand Blier, the first word that comes to my mind is not really benevolence. They are extraordinary people, not necessarily nice, and their primary concern was not to please or be likeable.

Chabrol, with his magnificent human qualities, dissected the bourgeois milieus, their neuroses, their perversities. He couldn't have done that with such lucidity if he'd regarded his contemporaries with benevolence.

And Buñuel, courtesy and manners wouldn't have helped him portray society or religion as he did.

All those great filmmakers weren't trying to please people or be considerate, they had their qualities and defects, but every one of them was fascinated by human nature and society, which they revealed with a certain perspective, neither sweet nor indulgent, but true.

And that's why cinema was a few years ahead of its time and why it was the pulse of the future society.

When Chaplin released *The Dictator*, when Ferreri was making *La Grande Bouffe*, or Blier *Les Valseuses*, they showed the truth of their times.

The same goes with the great Italian directors: Vittorio De Sica, Dino Risi, Mario Monicelli, Luigi Comencini, or Bernardo Bertolucci for instance.

They depicted what was in front of their eyes, things that many people couldn't see because they were blinded by their good consciences.

It's become much more difficult today to be at the very heart of the era as they were. Not because there are fewer talents, but because the era is different. Society has evolved. Everything changes so swiftly now that it's become extremely difficult for fiction to capture & depict reality.

A reality that surpasses all fiction, including the most lucid and the most tragic fiction.

But everything is not however lost.

There are still authors and directors with, despite everything, a strong enough vision to identify that reality.

I think for example of Abderrahmane Sissako. With *Timbuktu*, he simply tells the story of a contemporary village in Mauritania. He shows us a truth.

Same thing with Jafar Panahi, who reveals the true Iran with his film *Taxi Tehran*.

Equally with Jacques Audiard. *Dheepan* depicted the fate of a migrant a few months before the plight of those refugees became a hot topic.

That's what the great auteurs of cinema have always done — they give their own vision of the world, with simplicity, strength, emotion, and great lucidity.

Since society has changed, the cinema itself also had to evolve.

Of course, the cinema was always commercially motivated, but for a long time the poets and artists had people with whom they could talk and make projects.

There were real producers who were willing to get money for them, like artists in search of patrons. I think for example of Serge Silberman or Jean-Pierre Rassam.

Then there were the big production houses, like Gaumont, which occupied the field. When they worked with other artists like Toscan du Plantier, it was still fine, there was culture and it produced cinema. Toscan took Federico Fellini, Akira Kurosawa, Joseph Losey, Satyajit Ray, Andrzej Wajda, & Ingmar Bergman under his wing.

Today, it's television that holds the power.

And when a poet has to confront a "decision-maker," he has very little chance of winning.

The decision makers are people whose main tasks involve building models, writing specifications, and making schedules. Their job isn't to encourage poets, but to

make products for their channels. Mastering the medium and the message, as Jean-Marie Messier said.

For them, film projects fall into three categories: what can be broadcast during prime time, what is vacuous and innocuous, and what may be broadcast only at midnight or what cannot be shown on TV.

And what cannot be shown is censored straightaway. Censored because it isn't mainstream.

It's the same as in communist countries during the Cold War.

The projects that those channels give the go-ahead to often lead to very bad films, because the creators are obliged to replicate the channels' standards, to respect that censorship if they want to work. There are more and more commissioned films, therefore fewer and fewer directors and auteurs. Because on a set, you need someone who leads with a vision, and when TV is in charge, the leader is no longer the director, TV is. For a private channel, TV leads; for a public channel, the government does.

Therefore, the movies they finance are less cinema than the TV movies released on the big screen.

I don't know who would support Buñuel or Ferreri today; they wouldn't find many people to listen to them, let alone to make their films.

Fortunately, there are still artists with strong personalities who won't let themselves be confined without a fight. Guillaume Nicloux, for instance, still happens to

subtly include a certain strangeness in his films which contrasts with everything that one usually sees.

What I like on TV are the series.

Series really do work, because they are, and from the beginning, television products.

It's something that was born with TV and has always existed.

It's somewhat equivalent to the great novels of the late nineteenth century, those of Alexander Dumas, Eugene Sue, and Ponson du Terrail. It was a genre in itself, different from the novel itself; it was written for the newspapers, and the authors were paid by the line.

TV fiction also began with feuilletons: there was *Thierry la Fronde*, *Jacquou le Croquant*, *Vidocq*, *Les Dames de la côte*. Today we have *The Wire*, *Breaking Bad*, *House of Cards*.

All the channels are following that trend; we have even moved on to the next step, which comes after TV: Netflix productions for example, made directly for the Internet.

With those series, channels really have the opportunity to become windows to today's world, to be witnesses to society, to express cultural identities.

A few years ago, with Josée Dayan, Étienne Mougeotte, Jean-Luc Lagardère, Jean-Pierre Guérin, and a few others, I worked with some TV people to adapt Dumas, Balzac, and Hugo to recount the story of Napoleon.

It required great energy, because it was necessary to negotiate with people who were thinking especially in terms of profitability.

At Cannes, at MIP TV, I met the owners of channels from around the world and made deals with them: *The Count of Monte Cristo* was bought everywhere. In the United States, on Bravo and ABC, it had a record audience. I had more trouble with the BBC, which didn't take kindly to the French arriving on what they considered their territory. I ended up giving them the broadcasting rights to *Monte Cristo* free of charge by making them promise to commit to the *Napoleon* production if they had more than twenty-five percent of the audience. They weren't very loyal at the time; they cut each episode into two parts and broadcast them at 6 PM, the most difficult hour. In spite of that, they had four times as many viewers than usual during that time slot. They always denied it.

For *Napoleon*, I managed to find four billion lire from Italian TV. I returned to Hungary where I had filmed *Cyrano*, where I met the Minister of Defense, Viktor Orbán, who was still reputable. It was before he built walls to prevent migrants from entering. He loved football, and when I met him, I brought Zidane's jersey. I had discussions with him, with all the officials, to get permission to shoot in the NATO training camps. They had placed one thousand two hundred men and two hundred and fifty horsemen at our disposal for more

than one month. We were able to reconstruct five of Napoleon's great battles.

Something of the French identity has been taken up by the world thanks to those films, and I'm very happy about it.

When on official travel to China, Lionel Jospin took a copy of *Monte Cristo*. I went there too, and met young filmmakers full of talent, like Zhang Yimou. I brought them the Balzac I had shot with Josée Dayan. All those films were later broadcast on Chinese TV several times.

It's really the good side of the evolution of TV and cinema, and due to globalization, despite its negative aspects, we have the opportunity of sharing a cultural identity with the whole world.

It's a great opening to the world. A way for every country to exist everywhere.

Yet, it's only possible if such countries encourage their filmmakers to express themselves, to explore their cultures and their societies.

It's something essential, the real *raison d'être* of all those images that unfurl everywhere.

But for that to continue to exist, we must really fight with the national film organizations to give their own filmmakers opportunities to realize their work, to love them rather than to be invaded by standard global products.

Ninety-seven per cent of the films that are broadcast all over the world are English-language films. There are ten world stars, all of them Americans. Before their special effects films that look more like toys than movies, the rest of the world is struggling to exist. And they know how to skillfully mix propaganda and cinema, their vision of things prevailing over the truth.

That's why major festivals, like Cannes, like Venice or Berlin, are crucial. When you present a great film, you feel a truth, an emotion, which is the ultimate testimony of a culture, a country, an identity. With Ozu or Kurosawa, one reaches the soul of Japan.

The same thing happens today with a lot of films coming from the former countries of the East or China, for example, with someone like Jia Zhang-ke, who perfectly conveys what that country is, which can continue to surprise us.

Renoir, Truffaut, and Pialat did nothing but show a certain French spirit, whether through complex historical films, or simple love stories from which a shattering truth shone. The "You have beautiful eyes, you know" of Prévert, said by Gabin, filmed by Carné, was then the truth of the time, of France, and a universal emotion.

Before I knew him, I took Francois Truffaut for a petit-bourgeois. I had a bit of trouble with some of his films because I knew almost nothing about cinema. Then I saw *L'Enfant sauvage* — with that, he held my attention ..., and when I met him, it became obvious.

It was the same thing with Maurice Pialat. He was bursting with life, a great adventurer, with unbelievable love stories, which Chabrol confirmed to me much later. Truffaut recounted his stories with elegance & genuine discretion, but in the end, he was the street kid he had always been. He felt the world, things, and people intuitively, and that truth was in his cinema.

Maurice Pialat, it was the same thing with him. It was sometimes difficult to hear & understand him, like all radiant people, people who have immense generosity and immense humanity. He spent his time questioning the honesty of the people who do this job. He was monstrously human, Maurice. So he loved monstrously. And he was monstrously provocative also. There, we are very far from benevolence.

Many filmmakers have also been great painters, such as Kurosawa and Fellini, whose preparatory drawings, now called storyboards, are real masterpieces. Maurice brought painting to the cinema, as Truffaut brought literature & life, or Jean-Paul Rappeneau music & rhythm.

Even if Jean-Luc Godard possesses something of the painter, with a film like *Passion*, for example, which I find great because of his sense of framing, he is to me more like a teacher who tries to educate by using others' philosophy.

Unlike Godard, great artists don't feel the need to explain things whatever the cost; they content themselves with revealing themselves in their entire truths.

For a long time painters had been the witnesses of an era, a society, a culture. In each of their works they expressed a particular way of seeing and of apprehending the world. Often taking the greatest risks. Like Gustave Courbet, whose paintings were confiscated by the government after the Commune, and who was forced into exile.

Nowadays, painters have the same problems as directors in relation to producers.

Artists have always been made by patrons. The great families of Spain, of Venice, or of Florence, supported the evil inclinations, the criminality, the mob mentality of their protégés. Caravaggio, Goya, Rodin, many of the greatest were real characters: tortured, troubled, disturbed. Passionate people often have deadly passions.

What kills us today is ignorance.

The new patrons seriously lack curiosity, generosity, & culture. After earning a lot of money by stealing many souls, they lose their own and want to buy brand new ones. They have the means, of course, but souls can't be bought. They might well buy prestigious auction houses, to artificially create artists who are worth nothing, still, time will sort things out. When working with artists, you can't get rich if you remain innocent.

I love buying artworks, but I'm nothing of a collector. I don't like particular movements; I simply have successive passions that I can't even justify.

And anyway, why would you explain them?

I won't try to explain the paintings of Odilon Redon and why they touch me. Or Rodin's red charcoal drawings, or Calder's mobiles, or Germaine Richier's sculptures. I'm not Godard.

I keep my paintings close to me; I never hang them up because I don't want to confine them in space. I want to leave them free, free to express everything they can express.

I stack them in a pile, and once in a while I take one out, one that asks to be free, so I hang it, and when it's done, I put it back in the pile.

I've let some of them go. I know that they're only passing through; it's very free, very joyful between us. Having them with me delights me, because of the privilege of being in the presence of something that draws out what is beautiful in myself.

There's nothing calculated in that, nothing premeditated. I don't make money.

I think there's nothing sadder than people who premeditate. It's like screenwriters who write for effect. Or writers who write according to the latest trend, what people want to buy.

Today there's one writer who stands out from the crowd. It's Michel Houellebecq. I love his novels because they are the exact reflection of our society. He simply shows what's characteristic of our time. There is no gratuitous provocation with him. There's only an immense

intelligent lucidity. It's free of lies. It's strong. Houelle-becq is a dandy, a martyr, in a certain way, as Beethoven was a martyr. He doesn't aim to please, nor does he aim to displease. He's doing his job. He's an artist, certainly not someone benevolent. A being apart.

So was Marguerite Duras, whom I loved so much, that woman who made silence speak. Many of the people who are presented to us as extraordinary writers have no flesh. Marguerite did have flesh, an incredible & anxious flesh. She was a landowner, much more down-to-earth and manipulative than those who incensed her. She was also monstrous, as Picasso could be monstrous. Or Simenon. Like all great people, true poets are monstrous.

Poetry is a way of living.

A poet is someone who dares to test the limits of his self, even if it's difficult — he has no inhibitions, he doesn't care about the herd, he doesn't care about being benevolent or not. At the risk of hurting those he loves, of shocking everyone, the poet remains loyal to himself. That's why he's always monstrous.

Marguerite was a poet.

Celine too was a monster. He's the only one who gives such life to punctuation. I've always been very attentive to punctuation. In life, you rarely score points. It's only narrow idiots who keep score. They who have definitive opinions, the mule headed. Guys who feel invested with a mission.

Whether in literature, art, or cinema, I have the impression that the artist and the poet are losing ground. There's more and more calculation, less and less truth.

It's true that with people like Truffaut, Pialat, Bertolucci, Monicelli, I had known another era. I didn't realize it when I was living it, I didn't particularly like it, but now I realize how interesting it was. In many ways, cinema was still a minor art, with all the carelessness that that implies. There wasn't that ubiquitous power of money and profitability yet; we were just trying to be as honest as possible.

I know that we shouldn't talk about cinema like that. After all, cinema is cinema; to me, only emotion and people matter. And I'm not going to say that I don't like movie people. It's as if I said I don't like someone because he's a Muslim or a Jew. People are not *only* Muslims or *only* Jews; they're also something else. Unless they're fanatics, they won't talk *only* about their religion, or force people to adopt a manner or way of thinking. But, unfortunately, cinema, and everything that goes with it, the market, the media, the industry, all those great spirits often oblige you to see things in their own way, or ask you to beat it. Discussion becomes difficult with them; there's no conversation any longer.

As I watched that César ceremony, I sniffed out the pompous fragrance of "benevolence" & hypocrisy that emerged from it, and thought that an artist must be really strong if he wants to survive today.

Or really innocent.

There are still honest, pure people, talented people, but today they have to struggle not to be stifled. They're scared right away.

In the late eighties, I went to Calcutta with Toscan to meet Satyajit Ray. Immediately, that city, it was really something, with all its waterways, all its rottenness, the truth of life and death mixed together. Over there, the dead smile. We climbed to the top floor of a half-demolished building, arrived in a room with books everywhere, and Satyajit greeted us. When you meet people like that, it's the very cinema that you meet. He was an extremely distinguished man, elegant and refined, of incredible vivacity. He had been Renoir's assistant. It was he who had the idea of *E.T.* He adapted a story he wrote in the 1960s, *The Friend of Bankubabu*, the story of an alien who becomes friends with a child, while during that time, all extraterrestrials were represented as threatening. The scenario was finally lost in Columbia's files and a few years later, *E.T.* came out as the success that it was. Satyajit was never notified when the project started; he didn't receive any royalties. It was Satyajit himself who told me that, showing me his book, which I read later, and in which we find most of the elements that later made *E.T.*'s success. Even then, nobody wanted to finance it. Not enough of a hit. With Toscan we both produced his last films. We could still find arrangements back then, people who would support us. I think that

would be impossible today. I often went to visit him afterwards. I was on the set of *The Branches of the Tree*, his powerful adaptation of *King Lear*. We had become very close. The first time he told me what his last film, *The Visitor*, was going to be, he simply said to me: "It's the story of a man who leaves India then returns years later to his family and tells them: 'God doesn't exist.'" It was wonderful. Especially in that country, where deities are omnipresent. In 1992, I convinced Michael Barker, the boss of Sony Pictures Classics, to broadcast Satyajit's films in the United States. He organized a retrospective that was a huge success. After that, Satyajit received an Oscar for all of his work.

Fellini had the same problem; at the end he couldn't finish his films. I often had lunch with him & Mastroianni. Fellini had the worst worries with his financiers, who were tearing each other to pieces over the distribution rights, which prevented him from moving on. He was telling me: "I'm gonna die, I'm ready to make my film and I can't make it." And yet, more than anybody, Fellini made cinema what it should be. Beyond a cultural, political, or social reflection, he urged you not to forget your childhood, your innocence. He was a seventy-year-old man who resurrected some of the emotions that you felt when you were six. It was his only concern — that return to childhood dreams: to their beauty, to their cruelty, too. He didn't want to make the world a better place, no, and he didn't want to be kind;

he felt no other mission than to restore the relationship that you, the child, had with the cosmos. Cinema, it's that, too.

A POLITICAL WORLD

Men of power fear nothing.

Or perhaps yes.

The sole thing that scares them is honesty.

It's what gives them that monstrous look.

Because they are forced to be monstrous.

And you cannot bear power if you're not.

There's never much concord among those who love power.

Just re-read Shakespeare. Or Peter Handke.

The madness of power has always existed.

Think of Gilles de Rais. Chevalier and Lord of Champtoceaux-sur-Loire, Marshal of France at twenty-four, national hero, fervent admirer of Joan of Arc, and murderer of one hundred and forty innocent children.

Crazed by power.

There's a magnificent text by Hugo Claus, *Gilles et la nuit*, which recounts that hell.

Even the most normal and honest guy in the world can be driven mad by power.

I've never met an honest man of power, ever.

When I say man of power, I'm talking about those who prevaricate, those who affirm that they're in charge

of our lives, who do things for our good, who lead us. All those who try to make us believe that horses don't fuck.

Power, that's what kills innocence.

Everywhere & since forever.

Just look at the history of France.

A history that isn't very glorious.

The story of so-called enlightened men of power who show innocent people the way.

Innocents who don't see evil and who become the martyrs of those who lead them to the front.

The French Republic is also that.

We have to keep in mind that that Republic began with the worst fundamentalists: Robespierre, Saint-Just, Fouquier-Tinville. Not religious fundamentalists, but political fundamentalists. Our great men. Three hundred years after the Inquisition, it was the politicians' turn to start burning people at the stake and cutting heads as pathways to the Republic.

After such a baptism of blood, the rest shouldn't surprise us.

With the way, for example, we've been behaving, we French, in the Maghreb or sub-Saharan Africa.

Who remembers the Voulet-Chanoine mission, those two French officers who, during the conquest of Chad, committed massacres so despicable that the army had to be sent to arrest them?

And Indochina? And Algeria?

After the Second World War, we found ourselves doing things as abominable as the Nazis made us endure.

It took twenty-seven thousand dead on the French side, and tens of thousands of young people who came back completely confused, before understanding that Algeria should be left to the Algerians.

I'm not even speaking about torture; André Mandouze spoke about that very well.

What the French government has done there is shameful.

We truly behaved like fucking bastards.

That's why I put Guy Mollet and others like René Coty in the same sack as Stalin or Hitler. The spirit was different but the result was not. Innocence sacrificed for the benefit of power.

Hypocrisy as well, as far as it concerns us.

A little specialty of ours, that hypocrisy, and very characteristic of our men of power.

It's enough to re-read Marcel Aymé, *Uranus* for example, to appreciate the smallness of character of those who have power.

Everything is there.

In France, there are many people just like Marcel Aymé's characters.

The proof is that we never talk about Aymé.

The Frenchman is afraid of him because he is afraid of the image he reflects of them.

When today I hear that Algerians here or there aren't grateful enough to us, I find it shameful.

We have occupied that country for nearly a hundred and fifty years without ever taking care of educating or caring for its inhabitants.

We were kings, little kings devoid of grandeur.

I was criticized for my friendship with Castro, but Castro, at least, actually worked to feed his people, to give them hospitals, education, and culture. Which is nevertheless the basis, the minimum of human dignity. He also helped establish literacy in Africa, struggled for states to free themselves from their colonizers without falling under American influence.

We can hardly say the same thing about our French governments, who spent their time pillaging Africa.

When Mandela was released, his first trip was to Cuba. To thank Castro for funding his struggle, for training doctors, for helping African organizations fight against apartheid from the start.

So you can guess what I think of the moral lessons of our men of power…

Power and the hypocrisy that goes with it is a fucking infamy.

And we're in the midst of dying from this scum.

France today, nobody talks about it anymore. I see it clearly when I'm abroad. It no longer resonates; it no longer exists.

If things go on like this, France will soon become a kind of great amusement park, a Disneyland for foreigners. We all risk ending up like morons with our berets; we'll make wine and stinky cheese right in front of the tourists; we'll let them pull our hair and mustaches; they'll come to inhale the smell of the French.

Of course French ideals have made their way around the world.

But if you take a second to look at them … Liberty, it no longer exists. They take it away from us. People are manipulated and tracked and they have no secrets anymore.

Equality, I won't even talk about it, it's always been a utopia.

Brotherhood, I still believe in it a bit. I think it can exist because I believe that humans are fundamentally good.

Even if because of the political spirit humanity grows stupider & stupider every day.

I'm speaking about the masses, who end up creating fear, for they are being frightened all the time. But the individual, as always, remains faultless. And he has great merit when one becomes aware of the world in which he struggles.

In France I see almost nothing but exhausted people, trapped people.

In the city, they are everywhere, whereas in the countryside, the Frenchman has become very rare.

In the countryside, it's truly misery, and it's in people's heads, in their eyes, that misery. They can't even talk about it any more; they can only endure it.

Yet, they are honest people, people who believe in some values, but values that, alas, are disappearing.

When I go for a stroll, I look at the guys in the countryside who are harvesting, struggling in the heat, and I think to myself, when they perish, that land on which they worked to death growing vegetables, that land which they cultivated for their children or grandchildren, that land which their descendants could inherit, soon instead it'll be made into a supermarket parking lot. In other words, there'll be nothing left.

When I'm in urban areas, I think of it, the land that was there before, those who took care of it. In Châteauroux, when I was born, there were fields around the town where people used to plow & harvest with horse carts like in the olden days. There were day laborers, people who would offer their help in exchange for room and board. All that no longer exists. That's normal, the world changes, and so much the better.

But even so, I'm happy when I arrive in an area where that spirit still lives, in China, for example, north of Sichuan, where there are still whole fields cultivated by men. For miles and miles you don't see a single tractor.

When shooting Benoît Delépine & Gustave Kervern's *Saint-Amour* with Benoît Pœlvoorde, where I played the role of a peasant, I saw how things worked in France.

We started at the *Salon de l'agriculture* in Paris. And then we went to see the farmers at home, on their land, *&* it had nothing to do with all the bigwigs at the exposition, who for the most part know how to play the grant game.

There, in the countryside, I saw really lost people, people who, between Brussels, globalization, and agricultural mutuals, are truly at their wits' end.

There are more and more rules, more and more standards, more and more decisions coming from powerful men, and all those things prevent the farmers from doing what they know how to do healthily, healthily and honestly.

They don't know what to do with their land, their cattle.

During the shooting, I met a breeder who suffered from a terrible hernia. He had to be treated, he had to be operated on, otherwise, he was going to die. I asked him what he was waiting for, and he told me that he couldn't find anyone to whom to entrust his cattle to. I wrote to the farm fund to tell them what I thought of them, that they were collecting the money but that they were unable to take care of a guy who would probably die, unable to find someone who could be trusted to replace him.

But hey, an innocent who croaks, who cares? Certainly not the powerful. That isn't what will prevent the director of the fund from giving us moral lessons.

As a result, people no longer say anything. We're in a silent country. They're so desperate, they're so frightened, they're so stultified by bullshit that we ended up cutting them off, which to me is the worst violence.

I speak like an ignoramus, I only speak of what I see … but it's true that all those politicians, all those speechmakers are such shrewd devils that one is necessarily ignorant before their methods.

And anyway, in the end, they'll always be right.

And the innocent are the ones who will pay.

How can we transmit anything to those children in such a world? How can parents still be models, since the values of those models no longer exist, are constantly bludgeoned and humiliated? That people cannot raise their children the way they want to because of a political system & a society that drives them to despair, it causes me a great deal of pain.

I'm not even talking about the unemployed. With them, it's simple. In France, they have no identity anymore; they've nothing left. And we want them to continue to believe in politics? But the ravages of politics, they endure that every day.

And we see the results.

When a society no longer gives you the means to find a job that opens your mind, when you come home at night and you find your wife with her problems, your children with their problems, and a TV that stupefies

you by telling you of yet other problems, which aren't even yours, all that is so chaotic that you no longer find a balance.

When you're young, you can still hold on, you have the energy, but as soon as the children clear off, you get old very quickly, and there's drink, depression, antidepressants, & at the end the explosion.

You abdicate.

Often, it ends as a minor news item.

There are suicides everywhere, not just those who put a bullet in their heads.

And even among young people, I see some that live in the street, who are hardly more than twenty years old, they're disconnected from everything; they're not even aware of things. You look at them, you see their faces change, and in two years, they're dead. Those are just catastrophic stories because it's catastrophic to be in that state. It's cruelty without a hangman, or with alcohol and drugs as the sole executioners.

They've been abandoned, and they abandon themselves in turn.

That's our society.

You can't be fragile, I tell you that.

We're far beyond Zola, we're no longer in that misery, here in Europe, we're no longer even with the proletariat — we have entered a kind of new thing called globalization, where we starve to death just as much.

This globalization would already have to be understood by politicians. They talk about it, but we feel that it's miles beyond them, that they are twenty years behind it. Whether it's about employment, immigration, or industry, they're trying to act as if nothing has changed over the last twenty years, and they make us believe that we can get by with a national policy.

But that's not the way to go.

On the contrary, one can only make it through by starting to free oneself of everything.

We don't need the political spirit.

The worker and the peasant don't need an organization or a trade union. To protect themselves from what?

One can survive alone, that's ok.

Everything is possible; we just have to admit it. It's the spirit that guides us.

Politicians, there's really nothing to expect from them, just simply enjoying our lives and finding the way to manage on our own and trying to live the way we want.

There's no political morality, that doesn't exist.

And I'm convinced that it's those people who will one day bring the worst shit imaginable; it's they who prepare it, that superb shit to come.

Anyway, how do you want them to run a program, whatever it is, in a world where there are so many differences? Between a rich man and a poor man, between a peasant & a citizen, between the North & the South?

That too, it's a tragedy. All that human and natural diversity, they treat it as a whole. They want everyone to conform to the same things, they throw rules and laws at us continuously, as if they couldn't understand or tolerate that everyone is different.

But basically, they know very well that they can't change much, so they just play a role, the role of guys invested with a mission, wrought with certainties.

But it's only a role.

And when it's not a role, it's even more dangerous.

It took an image that turned the world upside down, that of a little child on a beach, as if emerging from the belly of the sea, to make them finally deign to take an interest in the migrant issue, which has existed for years. In a different period, the migrants were Albert Einstein, Stefan Zweig, Billy Wilder, who fled Nazism, while other Jews remained in Germany. At that time, too, there was little interest in them. More innocents. All victims of politics & power.

After that, how can people not feel abandoned, more than abandoned even, taken for suckers.

That's what I hear in any case, what they tell me here all day long.

What moves me most is this deep confusion that I feel, a blend of pain and incomprehension.

It seems like people are lost, that they don't know what to do.

It's such a profound despair that there are even more and more people who want to vote Le Pen, that means turning back, throwing oneself into the arms of ignorance, through the lassitude of another ignorance.

If I were asked how I define the political spirit, I would say that it's what really prevents us from understanding.

From understanding and feeling.

That's what takes us far from the essential, because precisely, when one reaches the essential, one no longer needs the political spirit.

If the individual can make it through, it's certainly not because of politics, whatever that politics may be.

One can only escape thanks to one's passions, to love, and by starting to make peace with one's neighbors, even if they're different from us, which is a very simple thing, but a very immense thing.

Even if loving each other becomes difficult, because we're surrounded by negative waves.

When you look at all those 24-hour news channels, it's terrible. That information which continuously flows from the screens — it looks like a conquering army from a science fiction novel.

That's called the reign of information.

It's the world of Van Vogt, of Orwell.

And all that to show what?

Destruction, lies, and violence, again & forever.

We take advantage of the slightest war to broadcast it live.

And it's always the same people, the journalists with their cameras, or the so-called new philosophers who show up in their costumes ready to burrow through the ruins of ravaged souls like parasites.

With, also, that twisted habit imported from America of publishing on the front-page photos of corpses without any respect for the dead.

That's what St. Augustine wondered about tragedy: what is so pleasurable about depicting the suffering of the other?

And that violence is all the more violent because we continuously depict it.

It's a continuous flow, which little by little kills any idea of finding a solution to our problems.

How can we still love after that?

We live in a world that's no longer made for love.

We're far from the time when people like François Mauriac chronicled politics & society. Back then, the chronicles were respectful because they were done with talent, that is, they were both true and violent, but never coarse. They were refined.

Today, we're on social networks. It's another era. It's probably very good, but it's not going to help anyone to remain human. It's one more thing that's there to take our time, to take our lives, a time and a life that I don't want to give away.

But that's the way it is. I won't go against it.

How could I go against it, anyway?

No, really, I see only one solution to all of that, which is to click the button, to turn everything off. TV, radio, computer.

And to meet people who are struggling to truly live.

I believe that what tires me most today is trying to understand everything I hear on the radio, everything I read in the newspapers, everything I see on TV. And what makes me feel good is to go for a walk in countries where I don't understand the language.

I like to hear the language of Racine, that of Corneille, Hugo, even Audiard's language, but to hear that permanent cacophony of power, politics, and the media, it's beyond me.

Changing sidewalks to avoid cunts, I always did that.

The only difference is that there are more and more cunts, so I'm obliged to go farther and farther away.

Well, when I say cunts … I mean those people who prevaricate, who claim to take your life in their hands, to inform you, to take care of you, to lead you.

I'm talking about the masses, not individuals.

I don't spare myself; I was a cunt to many people.

And I like that, to be a cunt to many, and especially to other cunts.

To be considered a cunt by another cunt, it's wonderful.

Today, I try to be elsewhere.

In Kazakhstan, for example, a country that's four times as large as France and four times less inhabited, where the people are nomads who don't need a house to feel at home on the earth, that spirit is in their blood.

Or in the farms of Saransk, where the soil is still plowed, where micro-diversity is respected, where, since they cultivate without chemistry, there are still butter-flies & water lilies in the rivers.

There's no pollution there of any kind. We meet pure people who aren't contaminated by all the everyday shit that the men of power are pouring into our lives here in the West.

Regardless, they can say whatever they want about me … I know what I'm leaving behind, I know what I find, I know that I'm a person who respects others and who loves to live and to share. And that's the only thing that matters to me.

WHAT KEEPS ME ALIVE

I feel more & more like a vagabond. Nothing holds me anymore.

I can go anywhere. Whenever.

I always travel without a suitcase.

When I was young, I went from Châteauroux to Côte d'Azur; now I go from Paris to Vladivostok, but it's exactly the same thing, exactly the same need, the same curiosity.

When I left Châteauroux, it was to live. When I leave France, it's to live, to live more.

I've always traveled, I've always been a citizen of the world, I'm not someone who settles, I'm only a passenger.

When I stop, I see things too quickly, people, their discomforts, I feel them very deeply, I can't bear it, I prefer to leave.

Since forever, as soon as I arrive somewhere, I keep an eye on the emergency exit, I know that the moment will arrive when it'll be necessary to leave.

But wherever I am, I'm curious about everything.

When I arrive in a country, I breathe it, I'm interested in the people, how they eat, how they work the land,

where the products come from, how the animals are fed. It never ends.

In each country, everything tells me a story.

The landscapes tell me a story, a culture. Monuments, architecture, nature, food, everything speaks to me. I breathe in everything. Whether in a Mauritanian desert, at sea with Olivier de Kersauson, in the Amazon jungle, in a French province, everywhere I'm always on the lookout.

Always having the capacity to be amazed, that's what keeps me alive.

And what amazes me above all else, what always guides me, is other people.

A jaded person is someone who no longer observes other people.

I constantly observe people: their land, where they live, how they live.

There's never been a cultural barrier for me, no language barrier, no color barrier. It's the other's conviction, culture, life, and intelligence that continuously give me hope.

My sole strength is life; it's to look at people and to be with them.

I come without luggage and I learn.

There's nothing more important than knowing how to listen and observe.

Language was never an obstacle for me. When I'm in Russia, I always understand what's said to me. I don't

understand vocabulary or grammar, it's not what's interesting, but I understand people, their movements, their way of being, all that non-verbal communication, which is by far the richest and the most important. And the people understand me.

When we were in India, in 1983, Toscan was knocked on his ass because I spent hours with people without knowing their language. They would speak to me & I'd mimic them; we understood each other perfectly.

I'm free of the inhibition that people with a normal education often develop.

When I arrive in China, India, Russia, I arrive as I am.

As Cyrano says: "But there's nothing I walk with that doesn't shine, plumed with that honest freedom that is mine."

If ever I sense danger or aggression, I know how to escape. It was Dédé who taught me that: always a smile when you feel aggression, a smile & then you walk away.

But the fears that others may have, their apprehensions, I don't experience them until I've felt the danger myself.

In New York, in 1972, everyone said to me: "Whatever you do, don't even think about going to Central Park at night, it's terrible, it's full of drug addicts, there's violence, murders." It was others' fear, not mine, and I wanted to see what was really going on there. So I walked through Central Park at night, I saw people, I saw shadows moving away as soon as I approached, but nobody

called out to me. It's a bit like with a dog — if you're not afraid, it's not going to bite you. You just have to know not to be contaminated by others' fears or prejudices.

Well, after all, since I'm not as dumb as a wild boar, I won't put myself in danger. You have to know how far you can go.

I'm like St. Thomas, I only believe what I see; I only believe what I experience.

So I saw people considered to be the worst scoundrels on earth and, it's funny, I never spotted any of the flaws that they were said to have. Never.

They bore the fuck out of me with Putin, with Kadyrov, with Lukashenko, with all those people who disturb the sacrosanct consciences of the Parisian press. But my meeting with Russia has nothing to do with politics. It's above all a human & spiritual encounter.

I grew up with Russian writers; I learned to speak French through their literature, first with the *Stories of a Russian Pilgrim* when I was around twelve. It was a book that aroused my interest from the start because I saw that the author was anonymous and I was also anonymous. I liked that. And I considered myself a bit like a pilgrim, except that a pilgrim has a purpose, and I didn't know where I was going.

I loved that kind of literature far more than comics. *Tintin* for example always deeply bugged me. I thought he was a muckraker, a snitch, a copper. It doesn't surprise me that the Americans love him so much. I wasn't

interested in those comics at all. They were fucking stupid to me.

I preferred the *Stories of a Russian Pilgrim* by far. It's a book that has always accompanied me. Then, very quickly, I loved Dostoevsky, Pushkin. Long before I knew the country and its inhabitants, I was a fervent lover of Russian culture. It was the one that echoed more than anything the way I saw things, my agony. Tolstoy deeply moved me; Mayakovski deeply moved me. It was in Russian literature that I recognized human nature itself, as I perceive it, the fate of humanity. In Russian novels, people can't be good all the time, they can't be bad all the time, it's tiring. But they're Russian all the time. That is, they love ten times more intensely than anywhere else, they hate ten times more intensely too, and they say that they love or hate ten times more strongly than everywhere else.

It's a country in which there's no mountain to stop the wind that sweeps everything away, which allows every excess, including with faith, with love, with the love of life.

Every time that I encountered Russians, there was an immediate sympathy, a shared warmth. The Russians can be cunning, fickle, liars. I adore their madness, their violence, their paradoxes. They're a bit like me — they live the moment, but a moment that's immense. It's an abundance, and I love it. I find myself nowhere else but in the Russian spirit, in the temperament, fervor, and

faith of the Russians. Their relationship with religion, with spirituality, with all the drama that they put into it, it perfectly matches me. And they make me feel good; they feel my *muzhik* side, my way of seizing life. The Russians and I are as thick as thieves.

Even Bertolucci hired me at the time of *1900* because he was searching for a guy who looked Russian!

Then, in 1977, I met Vladimir Vysotsky, who was permitted to come to France to see his wife, Marina Vlady. It was the time when every night I played in Peter Handke's *Unreasonable People are Disappearing*, directed by Claude Régy at the Théâtre des Amandiers. It was a real crush. We spent fifteen days and fifteen nights together. His wife didn't see him very often and my family didn't see me very often. During those two weeks with him, I was really a Russian in Paris. He made me discover a lot of places. We spoke Russian, ate Russian, and especially drank Russian. I don't know how I managed to perform at night. I didn't know his work yet, I didn't know what a genius that immense poet was, but I had before me, with me, a magnificent Russian, a being of incredible humanity.

Yet, for a long time, I didn't want to go to Russia.

Stalinism and its offspring didn't interest me; I couldn't tolerate seeing people so humiliated in their daily lives.

I jumped at the chance to go when I heard the word *perestroika.*

I can say now that, when you really know Russia as I know it, you'll see how the Russian spirit reveals itself, expresses itself through its land, when you see those infinite spaces and the people who live in them, the great things built by the hands of those people, their strength, their presence, their energy, you'll understand why Putin is at the head of the country and why one needs someone of that temper there.

Putin, he's an old rogue, I've heard him talk to the oligarchs who are trying to suck the country dry — he doesn't have his tongue in his pocket. It's they who are afraid of him, not the other way around, as in so many other countries. And I see when I talk to the people over there how grateful they are to him for restoring their dignity in the eyes of other countries, which they had lost with that Elstine guy, who loved the drink and who collapsed in public before heads of state, like me with my scooter in front of the Parisian firefighters.

I've always believed that the real dictators were those who starved their people, but I've never seen anyone starve in Russia.

I see Putin regularly, and most of the time we talk about geopolitics. Last August, for example, we spoke for hours about Crimea. That region has always been considered sacred land by the Russians, for it was at Chersonese, near Sebastopol, that Vladimir I, the great prince of the principality of Kiev, the cradle of the Russian Empire, was baptized in 988. It was at that time

that Byzantine Christianity became the official religion of the State. Then later the country fell under the Ottomans' yoke until the Sultan of Constantinople, supported by the Austrians and the French, declared war on the Russia of Catherine the Great in 1768. In 1771, the Russians freed Crimea from the Ottomans. With the Treaty of Kütchück-Kaynardja in 1774, Crimea became independent. In 1782, its sovereign, the Khan Şahin Giray, appealed to the Russians so that the country was definitively rid of the incessant Ottoman conspiracies. With Potemkin, he organized the annexation with Russia, & in 1783 Crimea became the first Muslim territory definitively lost by the Ottoman Empire, for the benefit of the Russians. At the same time, in 1772, a whole part of the Ukraine joined the Austro-Hungarian Empire, under whose domination it remained until 1918. Then there was the Crimean War. In 1854, France and the United Kingdom declared war on Russia to support the Ottoman Empire. The siege of Sebastopol, narrated, among others, by Tolstoy, lasted for a year, during which the Russians resisted under the worst conditions. Five hundred thousand Russians died during the conflict. It was not until 1954 that Nikita Khrushchev, a man with a strong Ukrainian accent, an executor of Stalin's base actions, decided to cede Crimea to the Ukraine, the region in which he acquired all his political training and ascension. It was his "thank you gift" to celebrate the tercentenary of the Treaty of Pereyaslav, by which the

Cossacks of Ukraine had proclaimed their allegiance to Moscow. That act was decided in a few minutes, off the record, without any debate, by simple decree. That is hardly surprising on the part of Khrushchev who, a few years later, betrayed and then dropped Castro and Cuba in the same careless way as when he set up missiles in Cuba. Crimea, where at the time about two hundred thousand Ukrainians & a million Russians were living, was therefore subjected to the authority of a country with which it had very little history & culture in common. It's understandable why after being sold off in a few minutes to the Ukrainians in 1954, the inhabitants of Crimea answered yes by 96.6% to the annexation to Russia during the 2014 referendum.

When you're eating with a bunch of pseudo-intellectuals in Paris, it's obviously more difficult to understand. But *intellos*, the only people they don't despise are themselves, which is why they must be left to themselves. And those people are so used to talking about things that they don't know or live, they're of no importance. I'm not going to try to fuck them in the ass, anyway their asses are full, the Americans are already deep in there fucking them on and on.

The Americans, I met them at the Châteauroux military base. And I must confess, it was extraordinary. I was admiring those young guys, their discipline, their barracks with a strong smell of wax, their smell of chlorophyll. I was dazzled by those guys who ate omelet

sandwiches. I had never before seen anyone stuffing an omelet into a sandwich. I thought it was wonderful.

I never knew at the time how well meaning and puritanical that country was. In fact, when I say well meaning and puritanical, I speak of the image they've given themselves, because behind that puritanism, everything is very rigged.

I can barely tolerate real puritans; I can't stand it when they let morality stifle life. So with the fake ones…

It's necessary to see how, from the start, those colonists, often extremist, always terrifying, those so-call-ed "Puritans" coming from Holland, Germany, and England, where they were mostly a nuisance, have, with the hand on the Bible, eradicated the Indians, beginning with killing their buffalo, their food. Just read the wonderful novel by Jim Fergus, *One Thousand White Women*. It covers all of that.

Then, always with the hand on the Bible, those so-called Puritans, they established slavery.

Just watch Paul Thomas Anderson's magnificent *There Will Be Blood*, based on Upton Sinclair, to understand the madness of that country, its unscrupulous businessmen & crazy preachers.

The entire history of that country is more of the same; everything is always scandalous in America.

Today the Americans are two hundred years old; they continue to kill and they're not about to give up arms.

I'm accused of being a frequenter of Putin, but I would've found it much more insane to frequent the Kennedys and their entourage. All the Kennedys have been killed like common mafioso.

Bush invents weapons of mass destruction, manufactures evidence, provokes catastrophes in disregard of international law, and hardly anyone finds fault with it. In contrast, Clinton gets a blowjob, and they put him on trial!

It's something that has often startled me, that behavior, when I meet Americans. In front of you, you have tense, tight ass, plaster saints, but behind closed doors, they're lascivious fuckers!

It's the same with booze, the same hypocrisy. I especially noticed that, among women there, they give themselves haughty airs, yet in the restaurant, at noon, all of them drink like bums. It doesn't bother me, I think it's very good, that's how life goes, they live, you won't base your judgment of a society on that, but when it's coupled with such a façade of puritanism, a hypocrisy that you won't find among the Russians, it's indicative of something.

Same thing with the Americans' relationship to homosexuality. There are lots of gays in the United States, but they wouldn't dare to come out of the closet. Rock Hudson, Montgomery Clift, James Dean, all those people were forced to hide for a long time. And that still goes on today. How many actors, producers, and

directors assert their homosexuality? Practically none. And yet there are many. I spoke with Ang Lee, who directed *Brokeback Mountain*. He too was very surprised by the gulf that exists in Hollywood between appearance and reality. And in the US military, it's the same thing. Just look at John Huston's beautiful film, *Reflections in a Golden Eye*, adapted from Carson McCullers' novel — all of that is perfectly depicted. The relationship of men to homosexuality, women's desire, what's seen and what's hidden. We can also read the plays of Tennessee Williams.

Think of J. Edgar Hoover, the FBI director for more than forty years, who made records on every homosexual in hiding, all while being one himself!

Nothing has changed since then, and it will never change since it's linked to the hypocritical puritanism that rules there.

To puritanism *&* to power.

When we have power like the Americans, we always end up submitting ourselves to the only thing that remains to us, our fantasies, since we are the masters everywhere else, or we believe ourselves the masters. Take Dominique Strauss Kahn for example. And it's not new. Lacan already sent his rich patients to be whipped. When I did *Maîtresse* with Barbet Schrœder, a film about sadomasochism, it immediately became a cult film in America. People watched it in secret.

Everything is always done behind closed doors: reality remains in the shadows, light is saved for appearances.

Their incredible sense of communication explains it very well.

It's thanks to that that the Americans are the strongest, that they dominate the West. A completely perverse sense of communication, of course. They can invent whatever bullshit so as to exclude their enemies from trade with other nations. Yesterday, it was Iraq and its so-called weapons of mass destruction; today, whatever the cost, they will accuse Russia of every evil.

And that's precisely the misfortune of the Russians, who are incapable of communicating. They're terrible at it. Communication suffered due to seventy years of Stalinism and communism and the damage that both things caused to the word. But above all, it's not the Russians' nature to say one thing to your face and to do something else behind your back. They're not hypocritical enough to do that.

Since forever, the Americans have made us believe what they wanted us to, have manipulated us depending upon their interests. They highlight what suits them, & their propaganda works miracles. With that, it's as if they hypnotized all of the West.

For any Frenchman, for example, it was the Americans and them alone who saved Europe from Nazism. It seemed to me for a long time that the Russians' involvement, with their ten million military deaths, is far

from negligible in the fall of Hitler. When the Americans decided to intervene, the Red Army had already arrived in Germany. I think it was more urgent for the United States to avoid Russia's influence in Europe & to extend theirs than to organize the fall of Nazism. As for the "American" landing in Normandy, it was soldiers of fifteen different nationalities who were there. There were, of course, sixty thousand Americans, but the English were still more numerous, more than seventy thousand, not counting the twenty-thousand Canadians, the thirteen-thousand men of the 1st Polish armored division, the Czechs, Australians, New Zealanders, etc. And the way the Americans behaved at the end of that war was terrible, like real shitheels. In February 1945, a few days after the end of the Yalta conference, they bombed Dresden without any need to do so. The Germans had already lost the war, in two days, one thousand three hundred bombers dropped four thousand tons of bombs and destroyed that sublime city, full of history, in the same way that the fundamentalists today destroyed the city of Palmyra: just to make a demonstration of strength. The result: twenty-five thousand dead, the overwhelming majority civilians. In Japan, Emperor Hirohito had lost the war; he was preparing to negotiate when they flung their nuclear bombs on Hiroshima: a hundred and forty thousand dead. Nagasaki: one hundred and twenty thousand dead. There was no longer any military necessity to use

nuclear weapons; they did it anyway and they are, to this day, the only ones to have done so. And that after having imprisoned in internment camps on American soil nearly one hundred thousand Americans of Japanese origin who did no other wrong save for being of Japanese origin. We also ignored Operation Paperclip, with which the Americans clandestinely organized with the utmost impunity the escape of 1,500 Nazi scientists, many of whom had worked in concentration camps, who came to benefit the American industry and army, resulting in all their atrocious experiences. One of the heads of the research laboratories in Auschwitz, Dr. Otto Ambros, the inventor of Sarin gas, one of those famous "weapons of mass destruction," became a consultant to the U.S. Department of Energy.

Thanks to the Americans' excellent sense of communication, all that no longer exists; it's as if it had never happened. What the Westerners retain is *Saving Private Ryan*. The great heart of the American liberators. Once again, everything is a spectacle with them, and we get hoodwinked.

I remember, when I was in Cuba in 1995 with Fidel Castro, supposedly the sworn enemy of the United States, I was very surprised to find around him all the great American industrialists, who came to see him regularly. The boss of Coca-Cola spent his days with Raúl Castro.

I don't want to fall into the primary anti-American-ism, the Americans, basically, I like them, they're not all like that, but it's true that when it comes to power and their patriotism, they can make anyone swallow any-thing. But particularly intellectuals & journalists, who are consenting prey to their propaganda.

Do you believe that it's a model of justice, the Ameri-can life, with all those people under the poverty line who are treated like rats, not even accepted in hospitals if they don't have any dough?

I've never seen that in Russia.

Look at the Baltimore riots. Anywhere else in the world, it would have made the headlines; everyone would have felt concerned, but there, they didn't. It's poor people yelling, so no one cares. Those states are supposedly united, but each one doesn't care what hap-pens to its neighbor. One can kill innocent people in one state without anyone else complaining about it in an-other. Here, at least, when there's a killing in Marseille, even the people of the North feel concerned.

And the press applauds those so-called United States. They are our great mentors. A country where a person is legally executed every ten days, whereas the death penalty has been prohibited in Russia for more than twenty years.

The people of America have always slaughtered one another: first the English and the insurgents, then the colonists & the Indians, then the northerners & the

southerners. And they had clandestinely exported that obsession with divisiveness all over the world, establishing it in each country that they coveted, pitting one part of the population against another. That was the case in Central America, Eastern Europe, and the Arab countries. Today, it's the former Soviet Republics that they are arming to set against Russia.

They don't hesitate to support someone who is considered a war criminal in his own country, if that serves their interests, such as Mikheil Saakashvili, the former president of Georgia, now governor of Odessa in the Ukraine.

But that's how it goes ... against them, you can't protest. They rule. It's the Empire. We do what they want. Their wishes are commands. France sells helicopter carriers to Russia, but they never send them. And before the comedy of that weakness, India cancels a contract to purchase one hundred and twenty-six fighter aircraft, eighteen billion euros, to turn to the Sukhoï and the Russian MiGs. Finally, we sell helicopter carriers to Egypt, and we lose 250 million euros on the deal.

Everybody gets tricked by their supposed innocence. That innocence, of course, is only a posture, a disposition, politics, a communication strategy. Backstage, and for a long time, they start fires everywhere; they stir up shit wherever they go.

And for the French intellectuals, the so-called dictators, the so-called perverts, are Putin, Kadyrov, Luka-

shenko, *&* the others. The alleged enemies of human rights.

But don't you think that what's happening in India, to take another example, is a thousand times more terrifying than what's happening in a random Russian province?

India, where women are treated like shit, where according to the law, widows cease to exist after the death of their husbands, and they are banished, sometimes even killed. Isn't it much worse than any of those pseudo-dictatorships that have been blamed every day by journalists who have never left their perches? I myself went to India, with Catherine Clement, and we fought on behalf of the widows there. But that, no, we don't talk about it during dinners with leftist eggheads. They prefer to criticize Castro and to praise Obama. Which, coming from them, is still a bit brash.

I don't understand why people in France are letting themselves be suckered by all that shit. Political and media power show us only what serves their interests, and they manipulate us anyway they want. And no one ever wonders why they impose such things on us. When I see reality as those powers present it, I always feel like I'm watching a reality TV show.

As Peter Handke says, "It's extremely painful to be alive *&* alone."

I MISTRUST CIVILIZATIONS

I've always been fascinated by creation, never by destruction.

That's what I love in history, creation.

History fascinates me. It's the opposite of ignorance; it's the opposite of stupidity. I didn't learn it at school, but I imbibed it later. I felt the sixteenth century with *The Return of Martin Guerre*, the seventeenth with *Cyrano*, the Revolution with *Danton*, the Occupation with *The Last Metro*.

I even found myself one day at the Collège de France talking about how I embodied a Frenchman of the sixteenth century in *The Return of Martin Guerre*. I had just studied the paintings of Hieronymus Bosch and noticed that at that time the peasants were not quite upright, their expressions were still grimaces. I imagined shouts, screams made to scare others more than some structured language. They were halfway between beasts & men.

I've always been attentive to those realities, interested also in the origin of things.

I always wondered why a stone was there, how long it had existed.

When we were looking for oil with Gérard Bourgoin, we were drilling at a depth of four thousand five hundred meters & taking out tiny stones, *falun*, sometimes with shells, sometimes with oil stains. The feeling of being in the center of the Earth, and I was there, at the very heart of the history of mankind, I loved that.

I experienced the same sensation with the arrowheads that I found in the Mauritanian desert, on the set of *Fort Saganne*.

I love landscapes and their history, but I prefer the history of people in the landscapes.

The pyramids of Teotihuacan, those of Egypt … when we talk about the folly of men, it's that hybris which interests me.

When I am in Death Valley, I am of course in awe of the landscapes; it's as fascinating as if we were on Mars, but I think especially of those people who, one hundred and fifty years ago, passed through that desert with horses, women, children. That strength, that will, that very hell is etched into all the paths, in all the stones that I looked at.

The history of people in the desert is fascinating. Just as much as in the dampness of the jungles, you can quickly become swine, or behave like swine, as much as in the desert you can become a saint. Because you cannot fight against 140 degrees, you can only try to live it, to bear it, & if you don't have an incredibly strong will, you can't escape.

Those initiatic paths fascinate me. Those trips, those quests are captivating, the story of those men who were looking for something, who wanted to create something else.

I'm thinking, for example, of the journey of the American Indians, who originally left a region at the crossroads of Russia, Mongolia, China, and Kazakhstan, which crossed Siberia, the Bering Strait, to find themselves in America. The ambition of those men was incredible, their madness too.

Just like the folly that sparked the cathedral builders.

Today we're witnessing the reverse of that ambition, that creative folly. When you think about, for example, the Taliban, who destroyed the Bamiyan Buddhas in Afghanistan, which had been there for nearly twenty centuries, or the Islamists who blew up the ancient city of Palmyra in Syria.

They must destroy, destroy at all costs, but destroy to create what after?

If Hitler had won, how long would he have lasted? Destroy yes, but what would he have created afterwards? What was powerful enough behind his ideas to create again?

Extremism knows how to destroy, but it doesn't create anything.

It's like those Taliban, or any fundamentalist moron. What do they offer us then? You can't just destroy the world and wait to see what'll come next.

Because you think destroying leads to creation, you brute?

Never.

It's totally incompatible.

Destruction has always been deeply rooted in human nature. The sacrifice of Isaac by Abraham to begin with.

Although the most beautiful sacred texts, the Bible, the Koran, the Torah, have been conceived, there is always a moment when the destructive instinct returns.

In all cleverness there's a bit of nastiness.

Just look at the beginnings of Catholicism. They converted with force, they accused people of witchcraft, the Inquisition did its work. They burned the heretics who thought, after Ptolemy, that the Earth was round. As early as the 4th century, the Christians dismembered and burned Hypatia, an Egyptian philosopher famous for her fabulous works on astronomy.

We had to wait for those creators who were navigators like Christopher Columbus, the cartographers, the explorers who, driven by their curiosity, left their countries to succeed in denying the Church.

Then it was the Crusades, St. Bartholomew, the bloody mess until Hitler with his mustache and his pencil dick.

And today, Israel & Palestine, September 11, Daesh …

It's always the same story, just a handful of assholes to create fucking havoc.

It's exactly like in a classroom: there are always two or three little shits, no more, who make the thing unbearable for everyone else.

And there's no point in putting them in the hallway, you have to deal with them because it's a situation that we encounter throughout life.

We must endure those things.

And everybody thinks that the problem comes from those sick people, like that rabid old cunt Le Pen with his red jacket, but perhaps it comes more from those who support him, who identify with him.

And they're not difficult to control; their very ignorance calls for manipulation. They're there to "swell the ranks."

Look at the *Charlie Hebdo* massacre.

It's extremely violent what happened.

Terrorists had killed some intelligent cartoonists — may they rest in peace — who were also philosophers. And friends of mine.

Charlie Hebdo, I've often made the cover, & always in the same manner: the asshole, the drunkard full of vodka falling from his scooter. It doesn't matter, because that too is part of me. That's what Putin likes about me, my hooligan side.

Caricature is something very healthy. Even if I think that discussing sacred books, resemblances and differences between religions, their way of coexisting or not, is far more interesting than caricature. If someone asks

me not to caricature his prophet, ok, I get it, why would I do that if it disturbs him that much? I'd rather speak with him about the taboo.

But now, with *Charlie Hebdo*, we're no longer only dealing with religion — we're far, very far from religion, we're in politics.

And the conflation between those two isn't new.

From the beginning, what religion was first composed of was set aside in favor of politics. One could say that organized religions were invented, or at least propagated, by & for politics.

We had corrupted a relationship with the Most High, a true faith, in order to build a social structure.

Even in St. Paul's times, it was more about power than mysticism. And it's the same for everyone who rewrites the texts in their own way (I was going to say for their own aims).

Not so long ago I heard a Jew and a Muslim debating the commandment "Thou shalt not kill." For them, indeed, one has no right to kill, since only God has that power, the power to stop life. And man cannot usurp God's prerogative. On the other hand, we have the right to murder. To murder the infidels. When you murder, you don't take the place of God when you're crusading. To kill is a divine act, to murder a human act. We cannot kill, but we can murder.

Who can understand that? I don't.

That kind of nuance, it's the entire doctrine of religion; that's the great dilemma with interpreting texts for the benefit of one person or another.

From the moment you begin to interpret, you can make texts say whatever you want, and the reverse of everything.

It's the open door to the most brilliant bullshit.

It's the same with wars.

In war, we don't kill, we defend our homeland. Nuance!

And it's with that kind of bullshit that one is free to commit every monstrosity.

Power, once again, succeeds in corrupting innocence.

Whether it be for country, for honor, or for any ideology, power "justifies" the worst atrocities, the shittiest things. "I just obeyed orders!"

All that is lamentable.

And it's the same with every regime, especially with that very old and widespread regime: the use of religion for political purposes.

I see today that there are many Jews or Muslims who have lost their bearings, if I dare say so.

And yet, when you return to the texts, whether to the Torah or to the Koran, you have wonderful things, far more than in the Bible in my opinion.

Both have everything you need to live in perfect harmony, whether through the texts or through their deep understanding.

It's quite astonishing, moreover, when one reads the Koran, the number of Jewish prophets found there.

Well, no, there again it's politics that triumphs.

The mass that once more triumphs over the individual. Power triumphing over the innocent.

I saw it well when I shot *Hello Goodbye* in Israel with Fanny Ardant, the story of a couple making their *aliyah*. Most of the people I met, whether Jewish or Muslim, had no extremist discourse.

Then one day a Palestinian mother with a belt of explosives under her coat killed four Israelis. It was her husband, who she cheated on, who asked her to commit that abominable act to cleanse her honor.

A brute, once more, and it was left between the colonists & the fanatics of Allah.

We're not even in the Middle Ages with that; it's actually worse. Even during the Inquisition, which was nevertheless overseen by real masters of ominous bullshit, it wasn't possible to indoctrinate that much.

At that level, it's not a matter of religion any longer.

It's political hysteria.

And today the abundance of lies has led to such conflicts between Islam and Judaism that we could never untangle that Gordian knot.

There were, of course, people who tried to re-establish truths there, to have another discourse, but they were killed right away.

I could see them well when I was there, those young Zionist soldiers. I heard their speeches. They were very far from the ideas of Theodor Herzl, one of the first to express the idea of an autonomous Jewish State and who envisaged a Palestine where Jews and non-Jews would have the same fundamental rights.

A sublime idea, far too sublime for politics.

I saw people who were making their *aliyah* and who were already arriving with that terrible envy, an envy mixed with fear, to take the land. But in approaching it like that, it will never belong to them. Because there will always be war. As long as they don't understand that the earth is for everyone …

When I see that whole picture, I cannot help but think that the religious authorities, be they imams or rabbis, don't do what's necessary to change things.

And yet there is often so much intelligence and sensitivity among them.

But it seems that there is a kind of insane consensus there and that everyone is doing the right thing in order not to get along. They must have an interest in war otherwise they would've made peace, like the bringers of good tidings. We're once more in the "kill, no; murder, yes" bullshit.

And behind you are all those innocents, who serve as cannon fodder for a religious power that manipulates them.

I wasn't baptized.

I was born in a so-called Catholic family because that was Berry and that was the Berry tradition.

But we didn't have enough money to be baptized, nor enough for communion.

And in any case the priest had sent me out of the catechism classroom because it was said that I had drawn a naked woman, that I had a dirty mind.

I believe it was due less to the naked woman and more to being of a different social cast.

If I had been brought up among the bourgeois, I wouldn't have been sent into the hallway.

But when you're a child, and you have nothing, when you're alone, you lose your school friends, when you have no other place to go but that road where not to get cold or have fear you have to be one with a tree, with the sky, with a storm, with a mountain, with the cosmos, and you understand that all of that, it's also you, that you have it in you, that it's your breath, your breathing, you're not afraid anymore, you're not cold anymore, because you really enter into communion with the mystery of life & nature.

And it begins by loving what frightens you that you enter into faith.

Faith doesn't come about through praying but through living.

Everything around you, starting with nature and people, gives you that faith.

And it was that faith that pleased me more than one religion or another.

That thing that you have in your depths, which is related to breath, nature, & human nature.

That thing which you find at the root of every religion, which was there even before every religion. I think of the Vedas, of the shamans of Kazakhstan.

Then the religions arrived: Judaism, Christianity, Islam and, in a way, we began to regress.

They have of course brought about a certain structure, a social structure, especially, but also a great deal of ignorance. Another religion immediately confiscated and used them: *politics*.

Even the very fact of shattering the link to nature, to the cosmos, in order to preach only for one's God, and for one's religion, was extremely reductive back then.

I think that everyone should be allowed to read any religious book they want without betraying his or her own.

When arriving in Paris, I had practiced hatha yoga; there again, breathing was the key. Then I converted to Islam after having attended a concert by Oum Kalsoum. It's the sensuality, the feeling, the *suras* of the Koran sung by Oum Kalsoum that transported me to that spirituality. Yes, that sensuality, I found it in Islam. A religion open even to the poorest. I attended the mosque for two years. I used to do the daily five prayers. More than prayer, it's the preparation for prayer that I loved,

the way that one has to empty one's mind, to make one-self available to one's being, to one's breathing, to higher things.

Later, when I read Saint Augustine on the advice of John Paul II, the special quality of his being that seduced me was again his sensuality, his knowledge of nature, his experience. And I liked his way of addressing God, often with anger, with the anger of the unanswered question. And in Saint Augustine addressing God intimately, there's a barrier that falls, there's something of equal to equal. Intimacy is really about love, whereas seduction is more about formality. I understand perfectly that man who had questioned himself a lot but who, above all, had walked a lot, observed the world a lot, who had always been interested in the mystery of life & nature.

It's that very mystery that has always fascinated me, & that's what my notion of the sacred is based on.

The laic doesn't mean much to me, it bores me a bit even; it's often flat, without depth.

The other day I heard a young Muslim taxi driver who said, "You talk about secularism, but secularism is already the first of the intolerances." That's lucid, sharp.

In Russia, religion is very important; I met many people of faith there. Their religion is very demonstrative: they touch a lot, they caress, they kiss, they move. It's very physical. I love that.

Orthodox baptisms, for example, are sublime. There's an incredible sense of celebration, never vulgar, a rural

side that makes me think each time of Jean Renoir's films.

When you go to a Catholic church in France, you have people whose faces bear their pain; they're already crucified. The orthodox, no. There's a kind of joy in being together; it's a true communion with the rhythm of the Gregorian chants, their harmony, the choruses that really awaken what's spiritual.

Those are beautiful religious things.

There's a true faith, but not the fervor that can be found among some Jews or Muslims, that very great faith, which can almost seem like a state of possession and create fear.

The real danger isn't faith, it was never faith; the real danger is when man in all his arrogance, his perversity and ignorance, begins to interpret the sacred texts with the sole aim, not necessarily conscious, of putting himself in God's place.

Manipulation begins with that.

I think of the other brutes who don't even speak the language of the prophet but who blindly massacre in his name.

In Russia, faith never blinds. There's not that spirit of seriousness, of gravity, that can be found elsewhere.

There, as everywhere among the Russians, it's the passions and innocence that make things happen. It can be terrible, violent, whatever you want, but it's never serious.

It's mostly very human.

When you read *The Way of a Russian Pilgrim* or *Father Rafael* of the Archimandrite Tikhon, a *starets* who has a very particular language, none of those books are like the ones that deal with our Western religions. At home, they're always deeply rooted in everyday life, expressing a faith that's an integral part of their breathing.

It's absolutely not intellectualized as in France.

There's really no jesuitical style in Russia; things are always simple, frank, direct.

It's that simple faith that I like to find there.

That's why I like to go to the steppe, to its silence, to those immensities that allow me to really return to myself, to reconnect with life, nature, the cosmos, which allow me to cleanse myself of this world, to find a certain availability, the one that I always had, when I was young, when I slept in the ditches, when I walked in the forest for hours & hours.

It's a way of returning to myself.

What I also experienced completely when I had visited Shaolin.

I had great adventures at the Shaolin Temple on Mount Song, one of the five sacred mountains of China.

In that monastery founded in the 5th century in honor of an Indian monk, where kung fu is practiced, each fighting monk concentrates with such intensity, similar to that of a Zen archer. Everyone has an inner animal,

which one doesn't choose, and whose faculties his body experiences. They have such mastery of their energy that they can forget suffering, make the pain of their bodies disappear.

When you arrive for a retreat in Shaolin, you begin with a silent group walk around a great Buddha. The master gives the rhythm. Then, you gradually enter into a meditative state. You empty your mind. Time settles in your body.

It's a bit like when you visit a grave in a cemetery. It's not during the moment when you arrive at the grave that you begin to compose yourself. It begins little by little, when you make the decision to go to the cemetery, when you buy the flowers, when you pass the cemetery door. You put all your troubles and thoughts aside so as to stand before the grave of the beloved. You gradually enter yourself; you make room. You put yourself in a state of availability. You become silent. Then, finally, you can begin to meditate.

At Shaolin, everyone sat in the lotus position, but I couldn't because of my knees. I just sat simply, without moving, and with no need to move. I was dead when I arrived there for the first time, physically exhausted, due to jet lag, because of my rhythm of life. I wasn't aware that three hours of still meditation had passed; I felt just as if I had had a very long night of sleep. More rested than ever.

It had absorbed all my poisons.

In meditation, you free yourself of everything that burdens you. You put yourself in a state of availability. In that state, you can finally elevate yourself & hope to separate yourself from your base nature.

The things that you can learn like that are fascinating. No, not learn, because I just don't learn, but *feel*, feel the things that are in you.

Through breathing, you approach the cosmic; you're far from the daily shit that's inflicted on you.

When you feel that, when you see everything the fighting monks of Shaolin are able to do, who are capable of things you wouldn't believe possible, when you compare your connection to the body, to the cosmos, to life, to theirs, you realize how narrow the mind has become here in the West, despite progress, computers, the Internet, the media, social networks, & similar idiotic weapons.

Perhaps some people will find the monks' view of human life ridiculous, yet is it more ridiculous than the thought that one spreads through a political party? I'm far from sure.

With us, logic and rationality still reign supreme. French philosophy, that of the Enlightenment.

Those Enlightened ones never enlightened me much, and they enlighten me less & less.

It's perhaps also because our way of being results from the Enlightenment period that I feel less & less French.

That famous rationality on which the French spirit is founded, with that, you're never at peace; you're always more or less in conflict with your neighbor. The texts of the Enlightenment are political texts, often texts of combat, texts that in any case separate us from innocence.

And the inexhaustible thirst for knowledge can also be the worst of plagues. From the flaying in the Sansevero chapel in Naples to the atrocious experiences in the concentration camps, we often murdered our neighbors the better to know them.

That passion for the mind, for rationality, which has always led to giving lessons, to wanting to enlighten the other, to civilize him, it bores me to death.

We don't need that so-called civilization. We can very well survive without it.

Look at *L'Enfant sauvage*, François Truffaut's film. The story of a kid who grew up in the wilderness and whom a doctor sought to understand, not educate. The nuance is important.

I definitely believe that we can survive in the wild. Even if politicians, teachers, and rationalists make you believe otherwise. That child, they caught him, but if they hadn't caught him, he would've died naturally, serenely, as beasts die.

As time passes, I mistrust civilizations even more.

I truly believe that one can live in complete simplicity, with nothing at all, and survive very well.

For many people, for a lot of people, the earth, it's what? Ten square kilometers, and again, I'm wide of the mark, too wide: it's closer to a square kilometer. They've nothing; they live on a very small piece of land that boils down to their dwelling, to their village, hardly more.

You don't have to go very far, to Morocco, for example, where you have people who live on bare ground, have no school, no hospital, no water, people who have to go to the well.

For them, however, that square kilometer is as rich, diverse, and varied as the thousands of square kilometers of a so-called "civilized" person who sees nothing in his vicinity, who doesn't even look at anything anymore, who watches nothing but TV, which makes him inert and blind.

The 'uncivilized' people, they're truly alive, a hundred times more alive than any of those civilized people. They still have an authentic gaze, a gaze in which things happen, a gaze that holds strong. It's important, a gaze that holds strong.

In their limited territory, there are thousands of things that we can no longer discern.

They aren't adepts of the Enlightenment, they aren't concerned with politics, their land isn't an idea, it's a space they have in them: a space they live, a space they breathe, a space they observe.

And if you want to meet them, you really have to be free of artifice, to go to them with nothing but your basic

humanity. Forgetting where you come from and bringing only your purest self. That kind of journey must be something very intimate, secret, human and spiritual at the same time.

But certainly don't go with a camera, like all those TVs that claim to show you what things are really like.

Or like those people who show you the world seen from the sky, no. To those people, I want to say, stop, land, ground yourselves & live!

We mustn't appropriate the image of those people who have nothing, who we never see but who are nevertheless there. The people who are already fragile, those programs kill them. All of a sudden it becomes "Koh-Lanta," an idiocy. Those people are harmed by our overwhelming civilization. It's a bit like feeding twenty-two pounds of sugar to a dog that lives on just one ounce of it a day.

No, that kind of adventure through the TV set, that false journey, it doesn't interest me. With that, the numb people in front of their screens feel like they've gone everywhere, knowing everything, but they haven't gone anywhere, and they don't know anything. It makes them a bit more apathetic, which is the last thing they need.

The media has really become like a debilitating drug for the insane. They'll soon succeed in making us abandon our very nature, like wild animals forced to weaken their carnivorous instincts through domestication. We too have been put in the circus. Everything is more & more constrained and less & less wild.

In the real journey, in the encounter with the other, there are, on the contrary, things that have no age, that are essential, and which are closer to religion as I understand it, that is, free of all its politics.

Because I truly believe that, contrary to faith and innocence, politics and its media outlets are merciless machines made for creating conflict and indifference. They play people against one another, or make them indifferent to one another.

And indifference to me is the worst.

It's a lack of life, a lack of culture, a lack of everything.

It's not even contempt; with contempt at least some zest remains.

To make someone indifferent is to make him ignorant, to put him in a state of depression, to kill the individual. To prevent him from encountering, from recognizing the other.

Even difference … this idea of difference, I don't find it interesting.

This difference, which is so much boasted of, is still a political thing.

Me, I am a Jew, he is a Muslim, I am an American, he is a Russian, I am a Catholic, he is a Protestant, etc. — all that is another way of erecting a barrier between people, to prevent them from approaching one another.

When one has established a difference, one has already retreated, or is at least hesitating.

A difference that doesn't exist outside of politics.

That goes well with the very political obsession of building walls: the Berlin wall, the West Bank wall, the Mexican border wall, and now the wall between Hungary & Serbia. One wonders where it will stop.

We must get rid of all that, of all those ideas, of all that shit, and recover our innocence.

To recover the spirituality that the people whom I spoke of earlier have in their eyes.

In the gaze, not in words.

There's really something very powerful beyond politics, beyond rationality itself, beyond everything we can formulate.

That, ultimately, is the relationship with the cosmos, with the Most High.

And when I speak of the Most High, I'm not speaking of the God of monotheistic civilizations.

I'm talking about our connection to the cosmos, that spirituality.

That of the Vedas, the Aborigines, the Mongol tribes, of all those people who lived in a pure way on an unpolluted planet.

Whether they were in their desert, their jungle, or on their plains, those people sought something beyond nature, in the cosmos, a bond with the Most High, a faith so that their family, their tribe, could be united through sharing a certain spirituality.

It was a search for life, for love, even if all of that could also be very violent, requiring human sacrifices.

But there was a fundamental innocence, a true balance, when it came to things, others, & nature.

It was the innocence for example of the American Indians, who had an extraordinary connection to their environment. They were nomads who took from the earth only what they needed. That was true wisdom, which was soon eradicated by the religious fanatics from Europe who, despite all their so-called Enlightenment philosophy, were far from innocent.

It's always brutal when politics starts to exploit faith. And the bond with the Most High is always what first breaks.

Yet it's that very connection that interests me, that fragile and deep faith that doesn't really have a name but which has to do with innocence, with nature and the cosmos, and with generosity as well.

It has to do with love, of course, but it's even more than that: — it's a way to be at one with what one feels, with what one sees.

An immense confidence.

It's something greater that I've always had in me, and it is, I believe, the only thing that saves me.

That saves me from myself.

To be able to transcend myself when I feel weighted down, burdened, when my soul is full of ecchymoses, as Peter Handke would say.

Handke, who also feels very strongly the same need for transcendence, which he evokes in *La leçon de la*

Sainte-Victoire, a narrative about his quest for the Eternal.

Eternity is not what helps you to breathe, that's a mistake, it's the Eternal that does.

It's a kind of grace, simplicity, a gift.

Painters like Monet or Bonnard certainly had that too. They were incredibly innocent. You can feel it very deeply in their works.

Not everyone has that gift, that innocence vis-à-vis what surrounds us.

Yes, it's true, we're born innocent, just as one comes out of the mother's womb, when one is thrown into life and has to trust the air that one breathes.

But that innocence, one loses it very quickly, as soon as one learns words, as soon as one begins to think.

The child is no longer innocent.

There are even a lot of kids who are vice-ridden at younger *&* younger ages.

But it's possible to recover that state of early innocence.

After you've gone through a lot of dirty tricks, when you've suffered too much shit, one of the only ways to keep on going is to recover that state of innocence.

Still, it's necessary to be able to make peace with all the shit that darkens your mind.

Start by accepting everything that you had coming to you against your will, accepting that you have your share of responsibility in what's happened to you. You've

fallen into the traps that others or you yourself have set, yet in order to recover your innocence, you must break out of them, but escape is only possible when you recover your innocence.

First of all, you mustn't be like those people who, whatever happens to them, are convinced that they're always right. You'll never hear a politician say that he was wrong … Never! Those people feel "innocent," always.

One's own guilt, one has to accept it. And innocence is certainly not the antidote to guilt. It's not about fleeing; on the contrary, it's about accepting ourselves if we wish to transcend ourselves. But if guilt weighs you down, faith and innocence allow you to embrace the world again.

And not only the world we're living in, the one that's above us, too.

It's said that the brain can be at its maximum capacity only about twenty minutes per day. With innocence, it's the same. You can have a few minutes of innocence throughout your day; if you can make peace with yourself without forgetting who you are or what you've done, that's quite a lot.

When I say that I'm a citizen of the world, it's the way I understand it. A citizen of a world in which people, wherever they may be, can at times experience a bond with others and the cosmos, a faith in all the things that surround them.

To experience that state of innocence & confidence.

And it's true that I find much of that in Russia.

Innocence has always been at the heart of the Russian soul. It's everywhere, in literature — in *The Idiot*, in *The Brothers Karamazov* with Alyosha, in Tolstoy's novels, in music with the Innocent's moaning in Mussorgsky's *Boris Goudonov*, an opera inspired by Pushkin's novel. One finds it especially in the great taste that those people have for spontaneity, confidence, and generosity.

Innocence is the opposite of control, which is always a lack of generosity.

That's why there's no innocence in the Free Masons, and in all spiritual orders of that nature. The moment that a secret order is formed, innocence cannot exist. Besides, the innocent frighten the Free Masons, just as honest people frighten politicians.

No, innocence is something completely free, disinterested, a simple state of being, free of any hope of compensation.

It has no end in mind.

The end is already political; it's still a political idea.

There is no end, just moments in which you can transcend yourself.

And be transcended.

It's far beyond love, perhaps on the side of the good.

It's also, in a way, a link with the Most High, a way of striving toward the perfect good, of striving toward holiness.

It's not about accepting everything. The "if they give you a slap on the left cheek then turn the other cheek" way of thinking, no, me, that bores me to death.

It's simply about finding a kind of peace with yourself & with others.

And it begins with silence.

Silence has always been an important thing to me. I've always been sensitive to silence, to its quality.

I've noticed, for example, that the silences of churches are not the same as those of mosques or synagogues. There's also another silence, the silence of nature, which can be surprising. The silence before an earthquake, for example. I've known that in Costa Rica. Suddenly the forest is silent, the animals are silent, there's a kind of muffled rumbling, all the insects fall from the trees, then there's nothing, not a sound.

It's found in silence and in innocence, but it's also found in music, that other language far removed from politics, far removed from power, that language which can reach the Most High.

For instance, when I'm with Riccardo Muti rehearsing the *Symphony fantastique* with the dozens of people who make up the orchestra, when I see how Muti transmits the urge, the desire to be in unison, first to his musicians, then to the public — it's there that I find my religiosity. There is silence before music, like a meditation, then a real communion. And the music that arises is truly blissful.

That's what carries & moves me.

Far from any idea, far from any politics, far from any power, far from any civilization.

Innocence.

THE OPEN DOOR

I believe that we die when we no longer have the desire to live. Irrespective of the circumstances of death.

Many people that I knew and who have left didn't want to live anymore.

They left at the right moment, when they had to leave.

We can die of grief, which is a poison.

But we can also die of boredom.

That's what I saw in Jean Carmet. At the end, life bored Jean. On *Germinal* he kept saying that he was pissed off. And then he was going to turn seventy-four and he didn't want to be. He didn't want to grow old; he didn't want to any longer. In his last months, he had set up an answering machine, which however wasn't like him. It was his way of preparing people for his departure.

With Barbara, it was the same thing. She had voice problems, chronic bronchitis. That irritated her when she was with me because we laughed a lot together and it made her cough. But when she found herself alone with herself at the end, boredom deeply pervaded her, leaving the door open to death.

Even if you have no suicidal thoughts, there's a moment when you can't stand life anymore, when you leave that door open.

Barbara was however an incredible living force who would dedicate herself entirely to others. When we had played *Lily Passion* together, she was on stage at nine in the morning for the evening performance. She needed to be settled in herself. It was incredible what she was giving; there was never anything mechanical about her, never anything faked, everything was vibrant, always.

She put her whole life at stake.

Because you can't reach that level of emotion if you haven't lived intensely.

You can't acquire that kind of emotion just through technique. It's exclusively a quality of soul.

That's what life taught her and gave her, the very things that she had forgotten but which existed in her and which, unbeknownst to her, emerged with a song.

It's what we call humanity.

Every night, it was different, there was no recipe; you didn't know what moment of her life would arise to convey the emotion. She didn't know it herself.

Nothing was controlled because for her, things were totally uncontrollable.

And quite definitely exhausting.

But she couldn't do otherwise.

Even the audience left completely shattered.

In a world where everyone holds back, such a gift of self to that degree was necessarily exhausting. There is, I suppose, a moment when all that intensity became too heavy to bear.

She must have felt that she could no longer continue, but she knew that she couldn't stop.

It's at those moments that one loses all of one's defenses, energy fades away, and boredom sets in.

I understand that; there are times when I feel empty, anesthetized of myself, where I can't stand anything anymore.

And when we can't stand ourselves anymore, diseases just catch us off guard.

But in spite of that, I've always found a strength in myself, the strength of life, my love of life & of others.

What truly matters is energy. And energy, it's simply not being afraid. It's to gaze into people's eyes with love.

Because the beauty of the soul is always found in the eyes. What speaks is the gaze. And no matter how imposing a gaze is, it must hold steady. There's nothing more beautiful and more exhilarating than looking at someone else's soul.

The people who age too quickly are often too self-consumed. But if one is more concerned about one's surroundings, one doesn't think about one's wrinkles or lack of energy.

Curiosity has always been strong enough in me to annihilate routine.

Routine is terrible, it's the thing that opens the door, or maybe no, rather, it closes the door; it's because of routine that boredom takes hold. And the worst, it's when you realize that routine is there; it's been there

for a long time. It's settled inside of you without you knowing it, without you realizing it. We don't know where it comes from, but one day, it's just there. And very much there.

Boredom is inertia. That moment when you can no longer move. That moment when routine has won, when your work, your responsibilities, your taxes, your wife, your family, your memories, everything that you carry on your shoulders paralyzes you. There's no danger anymore. Little by little, it's boredom that has taken over.

In such cases we must know how to put an end to regularity, we must have the strength to be reborn, to set down the road again.

The day when I lose the desire to discover, I know that death will follow closely behind.

When boredom takes over, there's not much to do anymore. And it's certainly not antidepressants that will get you out of it.

Antidepressants are crap. Me, I've stopped everything: all the antidepressants, all the medicine. I don't take anything anymore.

And it's true that it's better like that.

Well, I shouldn't say better ... In any case, I'm no longer under their influence, I don't let drugs disrupt my path, I face my own shit directly.

There are times for depression. In general, it comes at nightfall: that's when people start drinking. It's not very

worrisome; it's almost normal. But when the morning comes …

Me, I'm a morning person; I love the morning. But when you wake up in the morning and you don't have the urge to go on … then, it's really the beginning of the end.

Of course, everyone has flaws. Flaws, they're always present; you never get rid of them and it's for the best. Flaws are vital, in the original sense of the word. Because as long as you have vitality, you do everything to keep flaws at bay. And the more flaws you have, the stronger you can be, because the more energy you need not to break your teeth on them.

It's exactly like cracks in a wall.

If you want to go on, if you're honest with yourself, you find your way around them, you don't remain at the foot of a wall like an idiot because it might knock you on your ass.

You can also go to a psychiatrist who doesn't give a fuck most of the time. If it can help you, alright, fine.

But it's not strong enough to free you from your flaws, to put you back on track.

Analysis is less pleasant than life.

And it's not very helpful to mull over your past to try to compensate for your flaws. You won't be able to fix your wall. Why do you give a fuck anyway? It's better to leave it behind.

It's enough to find the strength in yourself to take another path, toward another wall, a wall that doesn't break you in half. Take some distance. Be on the move. Go elsewhere.

"'And you still see your cracked wall from here?'

— Eh, well, no, I don't see it anymore … But when I get closer, it's there again.

— Well, stop closing in on it, you idiot! Fuck off out of here!"

The only real freedom is that possibility of movement.

Of course, it happens that memory catches up with you; it's like the smell of shit, suddenly, it's there. That smell of shit is a sign that we must go even further.

They will say that you're trying to flee — no, you're trying to survive.

And it's with your strength to live, your will to live, your love for life that you can make it.

It's the same thing with the body.

You do whatever you want with your body.

And it stops when you want it to.

If there's one thing that pisses me off, it's that everyone constantly talks to you about their illnesses, their diseases, whereas the only thing that's interesting and unique about everyone is the way that they can heal themselves.

We only talk about the worst and we never talk about the best.

From the moment you can heal your spirit, you can also heal your physical body.

From the moment you can believe — I'm not speaking of religion, but of believing in oneself — you can recover from anything.

You can experience pain, or simply visualize it, be it physical or moral, and know what you need to make it disappear. Or what you need to get away from.

After my motorcycle accident, I was told that I would never walk again. The nerve was torn. The doctor explained to me that a nerve is like an electric wire, with a sheath that contains thousands of threads. Mine were cut. Fortunately, like the tail of a lizard, those threads have the ability to regenerate. For two weeks, while on my hospital bed, through my imagination I visualized those threads growing back, constantly trying to move my big toe. Even if it didn't move, I saw it move in my mind. Fifteen days later, it was really moving. A month later, I could move my foot. I cured myself, without drugs, without anything.

Only you can heal yourself, provided that you decide it, you alone. The only medicine that you need is what you have experienced & what you want to experience.

At my age, there's no harm in going for checkups from time to time; it's better to be safe than sorry. Today we have all the tools to explore the body; we can even take three-dimensional images of our organs.

The human body is of a complexity and a remarkable logic; it's a beauty that I find fascinating.

As you get older, you have to be active. To go against yourself, against your fears. Because of the pains caused by my motorcycle accidents, I often hesitate when I have to make a physical movement. I feel sick, stiff, but I do it anyway, I give myself a kick in the ass. I prefer to hurt myself rather than resign myself to immobility. And even if when I succeed I crumble like a big heap, at least I made the effort; I kept the right frame of mind. Because if your fears prevail, you lose the energy to go on, you become fragile, and you end up being unable to move at all.

But here again a will to live is demanded.

Which boredom can annihilate.

When boredom seizes me, I drink or eat a lot. Even if a dish isn't good, I still eat it, to know why it's shit, or to see if by chance there's not one good bite left in the end. But in such situations, when it's boredom that takes charge, when you succumb to your flaws, a dish is never good, you just eat to fill yourself, you drink, you don't even know why, you don't even know how much. It's the same with drugs. I took a lot before, because I was healthy. But when I'm in that state of boredom, in that malaise, neither drugs, nor alcohol, nor food have ever brought me any good.

When you think about it, it's very moronic to stew in one's own flaws.

Or very narcissistic.

That's not life.

When it comes to sports, for example, when I see someone win, it gives one a better feeling than all of the drugs in the world. Because, in a flash, you imagine all the training, all the dreams in the athlete's head, all his energy and his will to surpass himself.

That's life as I see it.

With athletic performance, with art, with books, there, yes, you're again approaching great ecstasies.

Even in my darkest period, I never had the temptation to commit suicide.

However, I'm very curious about it, but on a practical level. I always ask how people committed suicide. Did he hang himself? Did he immolate himself? Did he throw himself out the window?

It's very strange how we commit suicide. Mario Monicelli, for example, with whom I shot *Rosy la Bourrasque*, threw himself into a stairwell from the fifth floor. He was ninety-five. He wasn't depressed; he just didn't want to live anymore. It was a deliberate choice, in full conscience. He was still lively and alert, but he couldn't stand it any longer. He said to his doctor: "I see too much, that's enough, I'm done, it's over for me." And he jumped. Knowingly.

That's something which I can't understand, nor hardly imagine.

The energy it takes to do it.

I don't understand.

Or maybe he wasn't really conscious, or maybe, in a certain way, he was already dead before he even leapt into the void.

I try to imagine the time of the fall, like vertigo, but a vertigo a thousand times accelerated, the impact ... It's like people who immolate themselves, who douse themselves in gasoline and bring the match close to themselves ... even if you yearn for the void that comes after, how can you not think about the violence of taking action?

I really believe that suicide is a disease, a mental distortion. At birth man doesn't have that violence in him. You never hear a young child talking about suicide. Or he repeats what he's heard, but a child wouldn't think of that.

A child itself cannot imagine what suicide is.

Suicide is an adult word, an adult idea.

No, really, I don't find any impulse arising in myself to engage in voluntary death.

Well, in fact, ... once more, we can't ever predict our actions beforehand.

With human nature, anything is possible.

Even the worst monstrosities.

They too are a part of life.

I don't believe that any kid could envision ever becoming a Nazi. And in spite of that, one can be constricted by fears, be manipulated by some power, and become the worst torturer.

There's something terrible and fascinating about human nature.

That's why I don't have the right to judge.

I'm not even capable of judging anyone.

There are so many elements that can change the road we go down.

On the other hand, I judge the way people die.

In such cases, it's cut and dry.

When I'm broken down, I tell myself that I'm going to fall asleep and maybe I won't wake up tomorrow. I don't care. Not at all.

We always make too much of death. It's like cinema, where the actors always tend to overdo it instead of just letting go.

It's essential to know how to die.

And it's all the easier because death isn't difficult for oneself; it's the others who are in for it, those who remain.

And still ... our dead, we always carry them in our hearts. Guillaume, Marguerite, Maurice, François, Barbara, Jean, they're always present in me, all the time. Jean happens to come when I drink a glass of wine, Marguerite when I look at a house, Guillaume when I listen to certain tunes.

They're present all the time.

They were bursting with so much life that they remain. They don't fade away.

They also remain because I realize that what I lived with them was eternal.

My death, I see it as a beautiful peace.

And somehow also as a relief for those around me.

I won't be a thorn in their asses anymore; they'll be able to love me in peace, at last.

INNOCENT

My thing is the present.

The past doesn't hold me back.

The future doesn't interest me.

I don't give a fuck about what's going to happen to me tomorrow.

When you grow up like me in a survival situation, the present is the only thing that counts.

It's not a matter of how you're going to make it through in six months, but of how you're going to make it through in the very minutes, in the very seconds to come.

You've no other choice but to be in the present, and even a few seconds before the present, you must anticipate it.

The most beautiful thing that this survival situation has brought me is the present.

I always come back to Peter Handke's phrase: "I know nothing about myself beforehand, my adventures happen when I recount them." I could say that my adventures actually happen the moment I encounter them.

The need to survive taught me to be attentive to everything, to be available to everything.

And being available is not being empty, on the contrary.

Being available is being full, full of desires.

Nobody raised me. I didn't receive an education. The school, Charlemagne, Jules Ferry, all that, no, I took a different path. What I learned, I learnt it all by myself. The only French administration that taught me a bit about things was not the National Education Department, but the *gendarmerie*. As much as the teachers and the priests didn't want me, it always went well with the *gendarmes*. It was they who, when they caught me red handed, gave me some basics of civic education. And I've always been grateful to them.

But it's life & nothing other than life that taught me about life.

Life made it so that I spontaneously approached things that were right for me, things that made me feel good.

When you're a kid, and you're alone in the middle of the night on a deserted road, the whole world lies before you. If you resist anything, if there's one thing that you refuse to consider, you can guarantee that a mile later, that particular thing will come crashing against your face.

To be available is to go with the flow, never against it.

I got out of the mud, made my way in a society that excludes — I'm the weed that resisted, but if I had been against society, I never would've survived.

Anyway, how could I have been against it?

You can't fight against it when you know nothing.

I was never aware of social differences; they never affected me. At home, we didn't feel poor because we had no idea what it felt like to be rich.

Dédé used to sell *L'Humanité*, which he pretended to read because he couldn't read. Sometimes, when there were no photos on the pages, I even handed him the newspaper upside down. He 'read' it like that; he didn't notice anything. He was selling *L'Humanité* because it was a thing about friends, comrades as they used to say, but communism, social claims, politics, none of that ever interested him, or me either.

What interested me was life, the mystery of life, the rhythm of nature.

That was my thing.

Truly.

I found that there was nothing more ordered than the cycle of nature and its seasons. That, at least, was concrete; it existed and it appealed to me.

My life was in that.

For a long time, I regretted not having been incarcerated in a reform school, I even had a complex, then I realized that, thanks to that, it made me rich far in advance, because I never had any of the inhibitions that education can impose on you.

I've never been conditioned.

In the end, if I didn't learn anything, I lived everything.

I lived everything because I had that availability, that monstrous curiosity about life and people.

I've always been a lover of people who flit through life; of life and of those who inhabit it. Impassioned people.

I never judge people. Except the people who show me their flaws. But whatever their religion, nationality, culture, my heart warms up at the sight of people with whom I want to share things.

That's also a survival reward. You have no choice, you have to be curious about the other, what he's like, what he may or may not do to you. You have to pay attention to everything. Even things that you may not understand. Especially what you don't understand.

Since I wasn't wanted by my parents, since they made sure I knew I was an accident in my mother's womb, that I had survived the knitting needles, I was always very happy to be there, I always lived as someone who wanted to be a gift to others.

I always lit the Christmas tree.

Even though I never knew where the electricity came from.

When I arrived, Dédé and Lilette had family problems. Their parents had ruined their love story. My mother's father slept with my father's mother. They learned it from Lilette's mother, who couldn't endure it.

Dédé didn't want to hear any of it. But Lilette, she wanted to go away, to leave everything. And it was then that she became pregnant with me.

The worst kind of situation for a child is that he has to live a lie; that the adults make him carry a secret. I've never had to endure that. Everything has always been very clear, even if it was difficult. They wanted to get rid of me by every means; I had always known it.

Then when I was born, they told me that finally they were glad that I was there, that they were glad not to have killed me.

I'm a bit like the cat that one wants to drown but which got out of the bag and found itself alone on a bank. I could've become a wild cat, but I took advantage of that infinite freedom to open my eyes wide & observe my surroundings.

Knowing how to look, to see things, that's really the ABCs of life.

My parents let me go so I could form my own opinion of the world.

My dos & don'ts, I instilled them in myself, I never had any prohibitions.

If I had had the weight of the father or the mother on my back, I certainly would've had problems.

From the moment when you grow up in a family, there's so much shit to face: the mother's hysteria, the father's cowardice, etc.

Me, I've always been free of all that, free to educate myself.

I was always made to follow life, to go with a certain peace of mind wherever it would lead me.

I've always been curious about everything, even curious about the air that I breathe and which moves me, curious about everything in my surroundings.

I'm always on the lookout, constantly facing urges.

The urge to live, to know, to do. I move through the present & the present moves through me.

That's when I come face to face with Saint Augustine again: "What is time? If no one asks, I know. But if someone asks me & I want to explain it, I don't know anymore."

To me the present has always been eternity, the only eternity.

I'm often asked how I can live at this rhythm, to always be on the way out, always elsewhere. But that rhythm suits me; it's mine. I'm on a shoot for three days, then I cross through half the world to see vines, the other half to take care of a house, I come back — all that hustle & bustle makes me feel good. One moment follows the other. It's a different tiredness each time.

They say that I'm an actor, but I'm not. I never wanted to do theater or cinema. Life itself led me into those waters.

I could have also spent my life stealing cars, opening restaurants, or making business.

Even if I have nothing, but really nothing of a businessman. Otherwise I'd be like a trader, I'd have a humdrum life.

I'm just curious about life, & sometimes it leads me to share enthusiasms, to do things with people. I try to find some kind of companionship in everything I do. I don't make business, I make encounters.

And I won't break up businesses to make money as a hobby, like most businessmen. I'm not a vulture.

The dough, I don't give a fuck, it's not an end in itself, it's just a way to satisfy an enthusiasm.

It took me a long time to understand why I was doing this work.

Then I realized that it was for pleasure, for the love of words, of others, & of life.

And above all, doing theater or cinema, it was a good escape from work.

My vocation comes from that.

I didn't want to work, I wanted to live.

And with cinema I was given the opportunity to live in an environment where I could meet a lot of very lively people whom I wanted to watch. That's what I've always loved in that milieu, the abundance that can be found there, the excesses of life, enthusiasm, once again.

I never worked; I only lived, lived, lived.

Cinema in itself, I never gave a fuck about it.

I don't need it in order to be.

All the human encounters that allow a film to exist, yes — that's what interests me.

And the less I work, the more I can live the moment & share it with those around me.

Even if it comes to shit in the end, there's always been a great encounter, a desire.

And if it produces 1900, *The Woman Next Door*, *Cyrano de Bergerac*, or *Under the Sun of Satan*, it's all the better. It's the cherry on the cake.

But I derive no personal glory from it. Because I don't feel that I'm an actor.

I don't even have a technique.

My only talent is to be absolutely in time, to know instinctively how to inhabit the present time, the very moment, without ever resisting or trying to control it.

The present, again, nothing else at all. And above all, not work.

Perhaps it's this talent that shines on stage or on screen.

I don't know and I don't want to know.

First of all because I don't give a fuck.

Then because if we begin to examine how we work, we can't do it anymore.

And if we start to become conscious of how we work, then it's not worth it anymore.

As with everything, when you try to control anything, it's fucked.

The only true magic, it's always what eludes us.

In general, I don't like actors very much when they're only actors. They want to be actors too much, but they shouldn't be. Hence they often push very hard just to take a little shit. Or then I love them, but only if they're genuinely nuts, real lunatics. Those people, they must be pampered and then given a slap on top of the head from time to time.

I like being on stage with musicians performing an opera as much as I like being on a movie set.

What I really like is everything new. Everything that happens, everything unexpected.

That's why I'm not nostalgic. And that I don't attach myself to the past, to memory, to things that I've lived, to what's happened to me, to anecdotes.

I prefer life rather than the memories of life. Always be new.

I've had great moments with people, difficult times too, but none of that's important to me. It's life that has past, that's all. It's finished.

The moments, I live them in the present.

Whether they were beautiful or terrible moments, if you start dissecting them, returning to them, explaining them, you kill them.

They're like butterflies: they flit before the light, they're magnificent or frightening, but if they remain too long in that light, they die.

I'm simply someone who passes by, someone who is on a road, life. I go through those villages that are people,

authors, cultures, civilizations, then I tell the stories I hear.

It's my way.

I've tried following other paths & back roads. Thanks to my strength, I was able to follow them for some time, but in the end, all of them led nowhere.

No, there's only one way for me, that of life in the present moment. The others never took me anywhere.

I learned by walking, listening, and watching. By repeating the things that I saw and heard that were beautiful to me.

Whether with wine, movies, or cooking, they all come to one thing: to yearn to know, to give, and to share.

When I cook for others, I think of them, I say to myself, I want to do this or that for them. I have a medieval sense of hospitality. I love to receive. It really is a desire to share something, to spend a moment together, in the present. And it's true that when you give food to someone, when you feed their appetite, it's much more relaxed, there's less control, & that's when things happen.

With wine, it's the same thing — it's the appetite to live, it's the encounter.

When you feed people well, you don't even need to talk at the table, to explain life. You eat, you're at ease, you finish that off with a little *anjou*, it's bliss.

But all that can only exist if there's genuine humility before what the earth brings us.

When you have experienced that respectful anticipation with regard to the earth & its goods, you can only be fair, honest, and generous in your kitchen. When I cook veal, I know how it lived, I chose it; there was a curiosity, almost an intimacy between the animal & me. The same with a pig, you must kill it as you love it and as you are going to eat it. As you plan to share it. A pig, I caress it, I speak to it two hours before killing it, then I strike it, I bleed it, there's no scream uttered.

There would be a lot to say about Brussels and their fucking standards. All those men of power, once again, who claim to teach the farmers their own trade. You see where we've ended up. You can no longer kill at home; you have to go through the slaughterhouse where, because of their regulations, animals are stressed to death. It's shameful.

They don't know that one must comfort the sacrificed; they respect nothing.

That, it's really death.

While food, cooking, it's life.

And it's all the more terrible that people all end up resembling what they eat.

For me, a market, it's like a country: I go to see the varieties. I look, I ferret about, I sniff around. And it's the same with the breeders, with the animals. You really learn cooking by walking in shit a lot.

Wherever I am, I make sure to always eat well. If I don't like what's given to me, I sort it out myself, I go

into the kitchen, I open the fridges, I look at its contents and I cook fine dishes for myself & for others.

I let it simmer.

Because when you think about it, good food is always simmering, cooking by the fireside, the moment when all the juices of the meats & vegetables come together.

All this, finally, it's paired with great simplicity.

There's no message, no posture.

Just humility.

That very necessary humility.

Of course, I often happened to get a big head, even more when it wasn't warranted.

I was sometimes flattered by what I heard about myself, sometimes I believed what was said about me, I thought then, "Well, maybe it's true, maybe I am great …" I certainly had those delusions, but they never lasted very long because, very quickly, I got knocked on the jaw.

And when I messed up, I never dreamt of reaching those so-called heights again.

On the contrary, it always made me even humbler.

I realized very quickly that one cannot spend one's time pecking fruits, that what's essential is finding one's roots, one's tree, one's mushroom patch.

It's always necessary to let nature, once again, go at its own pace.

But it's true that I was often impatient & that impatience often made me a real shit.

I made mistakes.

I was a little wild, and unfortunately that wild character sometimes left me very lonely.

I believed that I could impose my freedom on others; it took time for me to accept that my freedom had no right over everything.

I apologized for that.

Respect for the freedom of the other is undoubtedly the most beautiful thing. And the most difficult.

In marriage, for example, you can't avoid it: one of the two always wants to change the other.

And that's the beginning of the shithouse.

Love, it lasts, around what, a dozen years. And then everyone evolves. Every decade there are changes. I did things at forty that I couldn't ever imagine doing when I was twenty. It doesn't mean that they were better or worse, they were different, that's all.

A couple, it's a bit like a tree. At first there are buds & then, as time passes, there are dead branches, and so we have to prune the tree, & even then, there are other branches that have grown elsewhere. It's human nature.

Even if we love each other, how can we resist the life that flows by?

We separate, we live other things, but it happens that we separate in pain and meet again with experience: fallen tears turn to smiles, to lovely embraces.

You just have to let the tree grow.

But whatever happens, don't ever think that the other will change you or you will change the other. It's just time that does its work.

The only clippers that can prune the hedgerow is time.

The most terrible thing is when you become dependent on the other. In *The Woman Next Door*, Truffaut has shown that very well, a woman and a man who are dependent on each other and dependent on love. Their attraction therefore turns into a sort of disease. A deadly disease. Like Stefan Zweig & his wife, who decided to die together before things changed.

That's the final marriage.

I've never been a sentimental maniac. And I believe more in everyday life than in marriage.

The rest, down there, sex, it's another thing.

But I was never dependent on that either. I was spared, for it wasn't really an obsession of mine.

I've never been a seducer.

Even when young, I wasn't concerned with sexual conquests. I was extremely shy; I didn't love myself enough. I wanked off a lot, a great deal even, but I didn't have a real conquest. Well, yes, I did once, a girl a little older than me. I was fifteen and she was twenty-one.

Self-confidence came a great deal later, at the same time as having confidence with women.

But I never suffered from unbridled sexuality.

I'm not saying that sex doesn't interest me, but I'm still more passionate about life, even if I love to talk

about sex, because sexual talk can also be poetic. But the pride of a male hunter who seizes a young female, that's never been very important to me.

I can very likely live next to a woman for a year without touching her.

I'm not a great fanatic about such things.

For me, the important thing is someone's behavior, their soul. How they move, how they see life, how they talk about things.

To me, beyond the body, women represent the spirit.

Without the spirit of a woman, without the sympathetic ear of a woman, I would have less refined words.

It's women who give us sweetness, who smooth out our rough edges, who help us to love and who give life.

Someone who gives life is necessarily an interesting person. As a man, you can just stop, breathe, & accompany them.

When I arrived in Paris, I met Elisabeth at Cochet Théâtre School. I was very surprised that she was interested in me since she came from a very bourgeois family. Since I came from Châteauroux, almost illiterate, it gave me wings. I was twenty, she was seven years older, I settled into a state of comfort, I created a family like I had never had — I was a father at twenty-one for the first time.

At the same time, I began to have great success in both the theater and the cinema. I saw that I aroused desire, even that of the guys. When I played a prostitute

in *The Boys in the Band*, which Jean-Laurent Cochet directed at the Edouard VII Theater, all the gays of Paris ran after my ass, and they even threw sweets!

Afterwards, there were a few love affairs, injustices, betrayals, everything that couples go through.

It often ends badly.

Because marriage fucks everything up.

Marriage is such a ridiculous thing.

Is there still someone who believes in the virtues of marriage?

Is it possible to marry at twenty, as I had done, and swear that you have always been faithful at sixty? Those who say yes, I find it bullshit, dishonest. Too polite to be honest!

And it's not new. Things like that have been said for a long time. Already Molière, in *The Learned Ladies*:

> ARMANDE: *What! sister, is the lovely name of maid*
> *a title that you are willing to abandon?*
> *You dare to take delight in getting married?*
> *Can such a vulgar plan be in your mind?*

> HENRIETTE: *What then has marriage in itself*
> *to compel you, my sister?* [...]

> ARMANDE: *Can you not imagine what repulsive*
> *pictures that word, when uttered, conjures up?*

Or what strange images it shocks one with?
Or how it soils the thoughts with filthy visions?
Do you not shudder at it? Can you bear,
sister, to endure what follows from that word?

I truly believe that a man *&* a woman are not made to live together their whole life.

We might meet again, becoming exceptional friends, but to share daily life and a bed with a woman forever, it seems to me a hypocrisy, even a lie.

After Elizabeth, I met Karine, we had Roxanne, and I was suspected of being made to have a child against my will, but it was quite the opposite.

I wanted all of my children, *&* I took responsibility for them.

After there was Carole, it was very, very good, we almost had a child, but we didn't.

Then there was Hélène, with whom I had stayed for a very long time in Cambodia and had Jean.

Today, there is Clementine.

Of course there were troubles and crises, but I got through innocently enough.

Without ever wanting to hurt anyone.

By the way, I've never truly broken with any of those women.

It's a bit like in Maurice Pialat's films, or like Maurice himself, who has always seen Micheline *&* Arlette. Nor did he know how to end things.

There are people who aren't afraid to say: "Well, it's ending now, I think it's over, it's time to split."

I don't know how to do it, I never knew how.

Then there's a moment when I leave, I leave everything and don't return.

I suffer, of course, it's normal, and the stories repeat themselves.

Every time women think they can change me.

Now that I'm old, I know the tune: every time they try, boom, I disappear.

No one ever changes anyone.

About such things, I prefer having friendships with women rather than having love affairs with them, for such friendships are much stronger & more intransigent.

Today, I have a superb friendship with Fanny Ardant, as I once had with Françoise Sagan and Barbara.

I had friendships more beautiful than any love.

More rewarding also, because they're more respectful of each other's freedom.

Respect for the other and his or her freedom, we always return to that.

With a woman, with a child … it's the same. What's important is not stealing the other's freedom, but to leave it intact. Or to try at least.

I don't know if I'm a good father.

What I know is that my children, I wanted all of them, took responsibility for them, loved them.

Men aren't born fathers.

Often, they only repeat the models they've had; they imitate their fathers. I didn't really have a model for that stuff, so I became my own.

I mean I don't necessarily have to be there on a day-to-day basis for their education, I come, I go, I don't force myself, but at least my children know, I tell them.

They have a free and living father who respects them, respects their freedom & their existence.

And anyway, whatever you do, one day, you'll always be judged by your children. For better or worse. Even me with Dédé, there was a time when I was a bit violent with him. And then with time I noticed that he was a man who was as he was. It was up to me not to idealize him; I just had to accept him, with his strengths and weaknesses. And today I thank him for what he did, for he left me the most precious thing: *freedom*.

I also did as much as I could for my children. Even if you never really do what you think you do.

And then for the children of actors, it's never easy.

There was a time when Guillaume was fed up with hearing nothing but things about me. Not only to hear it, but to swallow the bullshit that was said about me, that was terrible for him.

Have I helped them, my children? I don't know. In any case, I've loved them.

Maybe I loved them badly, but I loved them.

After a certain age, in any case, children no longer need their parents. Parents are there only to give their children love, and only when they ask for it.

For a long time, my life, it was others. It was easier for me to be seen than to see myself.

There was never a mirror in my house.

I couldn't stay alone in my room, listening to my own noises. Being alone with myself was absolutely terrible, an anguish, a true ecchymosis.

I had to go out, to go and observe the lives of others, to go and live elsewhere than in myself. I went out to the point of exhaustion, to the point of falling, peaceful, at last.

Like when I hit the roads when I was a kid, when I walked, I walked to exhaustion, with no other end than that exhaustion.

Now I'm finally able to live with my solitude.

I never feel alone anymore. I can remain entire days with my books. I feel very good. I read slowly, like a peasant.

I no longer run from myself, I make do with my reality.

I broaden my mind & then, I'm considerably lighter. I remain silent.

Everything is in silence. As everything is in the present.

And the peace that solitude brings is like a huge meal that one is never satisfied by.

Little by little I get to know myself. Sometimes I have inhibitions, prudishness, or shamelessness that I didn't suspect having.

That solitude, I had to tame it, but it wasn't easy.

But you know, that difficulty in being alone, it's an infirmity that's part of my illness, and my illness, it's nothing more than life, the love of life.

That being said, people do whatever they want with that disease; they can even make it a drama if they want to. Poor souls with no passions ...

The spectacle of the guy who drinks like a fish, if they want.

Of course I get boozed up, but it goes away, like life, like my anguish.

I certainly won't spend my time being addicted to alcohol. I'm addicted to life, and life is something vast, immense, which such people often can't imagine.

Being addicted to alcohol alone, how sad! There's drugs, there's sex, there's garlic sausage, there's pork knuckle, there's St. Augustine!

People and life intoxicate me far more than alcohol.

For actors, drinking often starts with a whiskey at five in the afternoon to overcome stage fright. It's calm, & at the same time it gets the engine going.

But often, it leads to lies.

The alcoholics end up drinking in secret; they're ashamed, they deny their need.

I'm not an alcoholic: when I have a shot, I never hide.

And it's always more from excess of life, whether it's marvelous or tragic, than from need.

As time passes, I don't swill as much as I used to.

To drink too much, little by little it kills the pleasure of excess; it ends in isolation, in withdrawing into oneself, into one's faults and one's narcissistic pains. You get tired. You get tired out right from the start.

And then, at my age, the day after … My liver is not what it used to be!

Of course, I've experienced things that I'm not proud of; I've experienced things much worse than what's been said or shown. I found myself in situations where my reaction wasn't pleasant, neither for the other, nor for myself. No one is immune from that. But since I'm not a masochist, I don't seek out those situations; instead, I try to avoid them.

Even if I take full responsibility for my shittiness & my blunders.

Because they contain something real.

And if we never lose control, it's often because we're a bit moronic.

That's why the things they say about me …

I didn't wait for the media to determine what I detest about myself.

Because most of the time, the media just displays what I detest about myself.

And at the same time, now, I don't detest that aspect of myself anymore because I know that I'm like that.

Whenever I read about myself, I have the impression that my goal was to shock, to provoke, that everything was calculated.

But I'm not a calculating person; nothing is ever premeditated.

I don't try to control anything, I just follow — and sometimes endure — my love of life & others.

A love that, as Francois Truffaut said, is both a gift and a curse.

In twenty years, I must have lost like 1,000 pounds, paid nearly 150 million in taxes, I had dramas, I left houses, I have furniture repositories everywhere, I don't even know what they contain, but none of it holds me back, none of that even interests me.

With me everything is in the present.

And I know I have no choice but to go on. To continue to fully enjoy the present, without attaching myself to the past, without worrying about the future.

I will even have to go much farther, much farther than that, to pass through devastating moments, moments that hurt, moments such as monsters or saints pass through.

Such will be my survival.

Perhaps it will bring my contradictions to the fore, but whose aren't?

Yes, those who don't live have no contradictions.

Because the more you live, the more likely you are to encounter & generate contradictions.

I may not be a normal guy, but what's a normal guy? What people call a normal guy is often just someone who's bored to death, a guy who doesn't really live, whose humdrum routine gently suffocates life.

So it's clear then, I'm not a normal guy.

I'm an alert guy, non-stop, a guy on the watch, almost at my own expense.

And sometimes, it's just exhausting.

Because to be curious about everything that moves can also be a tragedy.

When you live the present intensely, you are inevitably a tragic person.

Everything that I talked about earlier, all the destruction that we see every day, politics, the media, the impact that all that has on us ... on a daily basis, those things really leave me speechless.

It leaves me empty.

It even keeps me from being happy, because when you think about it, you can't live normally.

Or then, if you want to live normally, you have to exclude yourself from the world.

But if you don't want to exclude yourself, if this world is your life, then confronting such monstrosity becomes terrible.

If you're too sensitive, you can't even survive.

That sensitivity can also be a burden to others, to people who encounter me.

Me, I look at people; I can't do otherwise.

I observe them truthfully.

I've always been attentive to behavior, to the very breath of someone before he speaks, the direction of his gaze before he answers. Before I even ask him a question, I know him, I feel his way of being. The body has its expression. And it's true, I feel the discomfort, the pain, the pain that they try to mask, to conceal. I recognize their inner state through their malaise.

And I'd almost say that that's my trauma.

It's traumatizing to be aware all the time.

The love of the other is traumatizing.

Because you cannot see or feel all of that stuff, if you don't love the other.

And not only do you have to love the other despite the knife he's ready to kill you with, but the more you love the other, the better prepared you are to fight back.

In my case, it's not a question of defending myself anymore; I don't care about defending myself now, but that love of the other, it's like a real infirmity.

And when it hits me in the face, it's really strong.

But hey, it's not because some people have hurt or let you down that you have to look at everyone suspiciously.

You shouldn't, definitely not.

You have to sustain your trust in life.

Because if you let the bad things that people did to you devour your life and your confidence in it, you end up seeing evil everywhere.

Guillaume was like me, he saw everything too.

And for him, it was really unbearable.

That flayed him.

It takes a lot of energy and patience to bear that.

It's exhausting.

And the most exhausting thing is that you cannot help but try to fix it.

To heal yourself, to heal the other, to try to relieve fear, discomfort, & suffering.

That's something important, reparation.

And it has nothing to do with forgiveness.

You can seriously hurt someone, he can forgive you, but who will heal that person?

All the work remains to be done.

That notion of reparation comes from King David. It's in no other religion.

Among the Catholics, there is indeed absolution, which is a kind of reparation for the soul. But why are we fucking about with the soul?

What counts in the soul is what you do with it in your lifetime, idiot!

I don't try to be a saint.

I'm not against it, but being a saint, it's tough.

The life of a saint is fucking annoying.

I prefer to be what I am.

To continue to be what I am.

An innocent.

Someone to whom things happen, who lets things happen to him without any premeditation.

Someone who moves through the beauty of things & is moved by the beauty of things.

I'm someone who trusts life and others. I'm not a suspicious person.

It's usually there that you get screwed, but it doesn't matter.

The innocent, he's like a wandering dog: he senses people, he gets closer and closer, and if he gets kicked, it's okay, he walks away, he'll go much farther.

It's not always pleasant to be an innocent; most of the time it's even burdensome.

An innocent man doesn't respond to every action.

The innocent never judges people.

Innocence is respecting others.

The innocent is also a moron, and has a pure side & is free of malice.

In the Bible, it says the innocents are granted good things. It's just a phrase, but it's total bullshit.

Innocence is a virtue; it's extraordinary to be innocent.

To look upon life & things with an innocent gaze is a privilege.

It's not knowledge, it's only a receptivity to things.

It's a blank page on which you can write your different colored variations.

It's not a way of considering life, no; it's a way of receiving it.

And it isn't a way of knowing it either; it's a way of recognizing it.

Etymologically, the innocent is the one who does no harm.

Does no harm.

Nothing but that very concept goes far beyond what religions teach us today.

Dédé, who was illiterate, was at ease being an innocent with his Tour de France Compagnon nickname. *Berry, the Well Decided.*

That's beautiful, the Well Decided, the one who decides to do good.

Not to harm.

The innocent.

Being an innocent.

COLOPHON

INNOCENT

was handset in InDesign CC.

The text & page numbers are set in *Adobe Jenson Pro*.
The titles are set in *Didonesque Display*.

Book design & typesetting: Alessandro Segalini
Cover design: Contra Mundum Press
Cover image: Federico Gori, INNOCENT, 2017. Ink &
enamel on aluminum, 39cm x 26cm.

INNOCENT

is published by Contra Mundum Press.
Its printer has received Chain of Custody certification from:
The Forest Stewardship Council,
The Programme for the Endorsement of Forest Certification,
& The Sustainable Forestry Initiative.

Contra Mundum Press New York · London · Melbourne

CONTRA MUNDUM PRESS

Dedicated to the value & the indispensable importance of the individual
voice, to works that test the boundaries of thought & experience.

The primary aim of Contra Mundum is to publish translations of writers who in their use of form and style are *à rebours*, or who deviate significantly from more programmatic & spurious forms of experimentation. Such writing attests to the volatile nature of modernism. Our preference is for works that have not yet been translated into English, are out of print, or are poorly translated, for writers whose thinking & æsthetics are in opposition to timely or mainstream currents of thought, value systems, or moralities. We also reprint obscure and out-of-print works we consider significant but which have been forgotten, neglected, or overshadowed.

There are many works of fundamental significance to *Weltliteratur* (& *Weltkultur*) that still remain in relative oblivion, works that alter and disrupt standard circuits of thought — these warrant being encountered by the world at large. It is our aim to render them more visible.

For the complete list of forthcoming publications, please visit our website. To be added to our mailing list, send your name and email address to: info@contramundum.net

Contra Mundum Press
P.O. Box 1326
New York, NY 10276
USA

THE MÆCENAS CONSTELLATION

The Mæcenas Constellation (MC) is an alternative patronage experiment composed of individuals who together will form the inner circle of Contra Mundum Press. Through its combined resources, the constellation will serve as an entity akin to a Renaissance patron.

Contra Mundum Press (CMP) is an award-winning independent publishing house that has published translations from Sumerian, French, Hungarian, Italian, German, Turkish, and Farsi, two world-premiere editions of Pessoa, and several bi- and multilingual books from a variety of genres. Our art journal, *Hyperion: On the Future of Æsthetics*, has an international readership stretching from the Americas to Europe, Africa, the Middle East, and Asia. Writers such as Erika Burkart, Quentin Meillassoux, Alain Badiou, and others have contributed original essays to the journal. Contra Mundum Press has also staged events and collaborated with numerous cultural institutions in New York, Budapest, Berlin, Paris, and elsewhere, including participating in international film and literary festivals. Since our inception in 2012, our publications have been heralded in the pages of *The Times Literary Supplement*, *The New Statesman*, *The Guardian*, the *Paris Review*, and the *Los Angeles Review of Books*, amongst others. To become a member of the Mæcenas Constellation is to express your confidence in and support of such cultural work, and to aid us in continuing it.

Becoming a member of the MC simply involves a modest pledge of only $60 per year. The funds received from such a membership body would not only help compensate for the bulk of the production

costs of producing six books per year, it would also provide some financial support for the different experiences the collective wishes to develop. Aside from receiving 2 books per year in advance of publication and a limited edition tote bag, you would be entitled to a 30% discount when purchasing any of our other books (which you would receive in advance of release to the general public). Additionally, you will be offered the opportunity of purchasing limited edition books only available to members.

Through our community of readers, we would then be able to remain an independent entity free of having to rely on government support and/or grant and other official funding bodies, not to speak of their timelines & impositions. It would also free the press from suffering the vagaries of the publishing industry, as well as the risk of submitting to commercial pressures in order to persist, thereby potentially compromising the integrity of its catalog.

With bookstores and presses around the world struggling to survive, and many even closing, we hope to establish this alternative form of patronage as a means for establishing a continuous & stable foundation to safeguard the longevity of Contra Mundum Press. Each individual member of the constellation would help to form a greater entity and so jointly advance the cultural efforts of Contra Mundum Press. A unified assemblage of individuals can make a modern Mæcenas.

To lend your support and BECOME A MEMBER, please visit the subscription page of our website: *contramundum.net/subscription*

OTHER CONTRA MUNDUM PRESS TITLES

Gilgamesh
Ghérasim Luca, *Self-Shadowing Prey*
Rainer J. Hanshe, *The Abdication*
Walter Jackson Bate, *Negative Capability*
Miklós Szentkuthy, *Marginalia on Casanova*
Fernando Pessoa, *Philosophical Essays*
Elio Petri, *Writings on Cinema & Life*
Friedrich Nietzsche, *The Greek Music Drama*
Richard Foreman, *Plays with Films*
Louis-Auguste Blanqui, *Eternity by the Stars*
Miklós Szentkuthy, *Towards the One & Only Metaphor*
Josef Winkler, *When the Time Comes*
William Wordsworth, *Fragments*
Josef Winkler, *Natura Morta*
Fernando Pessoa, *The Transformation Book*
Emilio Villa, *The Selected Poetry of Emilio Villa*
Robert Kelly, *A Voice Full of Cities*
Pier Paolo Pasolini, *The Divine Mimesis*
Miklós Szentkuthy, *Prae, Vol. 1*
Federico Fellini, *Making a Film*
Robert Musil, *Thought Flights*
Sándor Tar, *Our Street*
Lorand Gaspar, *Earth Absolute*
Josef Winkler, *The Graveyard of Bitter Oranges*
Ferit Edgü, *Noone*
Jean-Jacques Rousseau, *Narcissus*
Ahmad Shamlu, *Born Upon the Dark Spear*
Jean-Luc Godard, *Phrases*
Otto Dix, *Letters, Vol. 1*
Maura Del Serra, *Ladder of Oaths*
Pierre Senges, *The Major Refutation*
Charles Baudelaire, *My Heart Laid Bare & Other Texts*
Joseph Kessel, *Army of Shadows*
Rainer J. Hanshe, *Shattering the Muses*

SOME FORTHCOMING TITLES

Claude Mouchard, *Entangled, Papers!, Notes*
Pierre Senges, *Ahab (Sequels)*
Goethe, *The Passion of Young Werther*

ABOUT THE AUTHOR

Gérard DEPARDIEU has performed in nearly 200 films since 1967, many of them being with the world's most acclaimed directors, including Jean-Luc Godard, Bernardo Bertolucci, Marguerite Duras, Bertrand Blier, Alain Resnais, Marco Ferreri, Peter Handke, Francois Truffaut, Andrez Wajda & others. He is the recipient of the César Award for Best Actor (1981; 1991), the Venice Film Festival Award for Best Actor (1985), the Cannes Film Festival Award for Best Actor (1990), and a Stanislavsky Award (2006) from the Moscow Film Festival for outstanding achievement in the career of acting, amongst others. Depardieu is also a Chevalier of the Ordre national du Mérite & a Chevalier of the Légion d'honneur. In addition to being an actor & entrepreneur, Depardieu is the author of several books, including *Lettres voles* (1988), *Vivant!* (2004), *Ma cuisine* (2005), *Ça s'est fait comme ça* (2014), and *Innocent* (2015).

৭৫

ABOUT THE TRANSLATOR

Rainer J. HANSHE is a writer. He is the author of two novels, *The Acolytes* (2010) and *The Abdication* (2012), and a hybrid text created in collaboration with Federico Gori, *Shattering the Muses* (2017). His second novel, *The Abdication*, has been translated into Slovakian (2015), Italian (2016), and Turkish (2017). He is the editor of Richard Foreman's *Plays with Films* (2013) and Wordsworth's *Fragments* (2014), and the translator of Baudelaire's *My Heart Laid Bare & Other Texts* (2017), Joseph Kessel's *Army of Shadows* (2017), & Gérard Depardieu's *Innocent* (2017). Hanshe has also written numerous essays on Nietzsche, principally concerning synesthesia, incubation, & agonism. He is the founder of Contra Mundum Press and *Hyperion: On the Future of Æsthetics*. Other work of his has appeared in *Sinn und Form, Jelenkor, Asymptote, Quarterly Conversation, ChrisMarker.org, Black Sun Lit*, and elsewhere. Hanshe is currently working on two novels, *Humanimality* and *Now, Wonder*, and *In Praise of Dogs*, a photojournalism project with filmmaker & photographer Harald Hutter.

❧